YOU

SLAY

SCUM

...NICATION IS FUN

MAKE LOVE NOT WAR

UP WITH MINI-SKIRTS

CHASTE MAKES WASTE

SE... BEFO... FINA...

REPEAL INHIBITION

LET'S LOCK LOINS

PORNOGRAPHY IS FUN

COPULATION NOT MASTURBATION

LEGALIZE CONTRA-CEPTIVES FOR TEENAGERS

OLD ENOUGH TO FIGHT, OLD ENOUGH TO VOTE

MY BAG IS BEING

CIVIC RESPONSIBILITY LOVE AT WORK

BRUINS PUMP BEST

BAN THE BRA

Fornicate For Freedom

God is Alive, He Just Couldn't Find a Parking Space

LOVE IS AS LOVE DOES

MY CAUSE IS ME

MEAT EATERS ARE SEX DEVIATES

PRAISE THE PILL

GO INTERCOURSE THYSELF

Pot Peace Pussy Perversion

Even I Like Sex

...RISE

IF IT'S LIQUID--

WOMEN SHOULD BE OBSCENE AND NOT HEARD

If it

# ROBERT HEINECKEN: A MATERIAL HISTORY

**MARK ALICE DURANT**

Center for Creative Photography
The University of Arizona

2003

Magazine-page envelope, actual size, n.d.

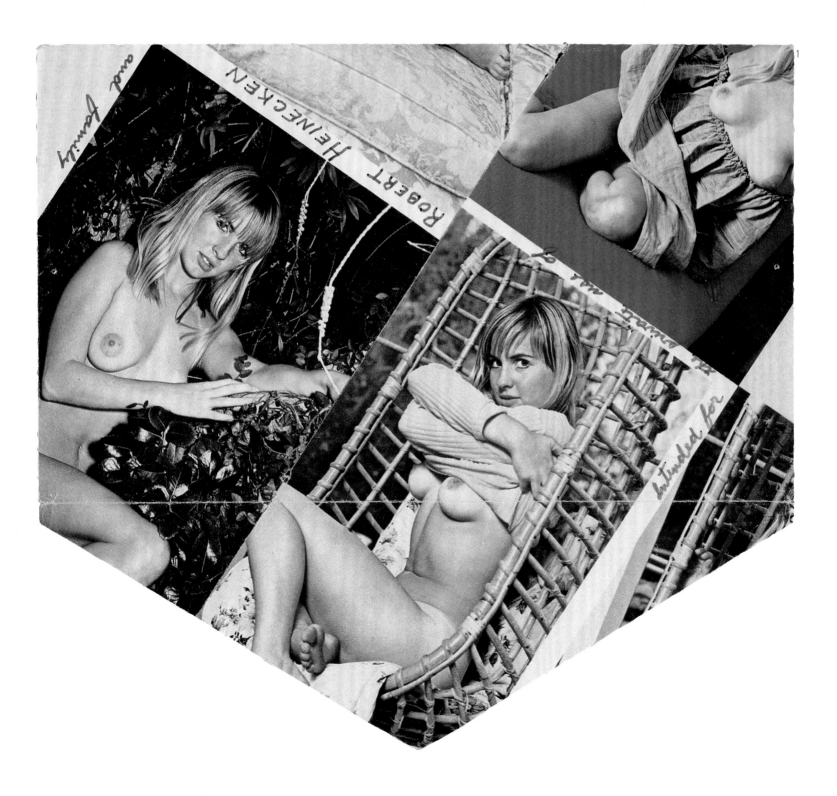

# Contents

# ROBERT HEINECKEN: A MATERIAL HISTORY

MARK ALICE DURANT

**ROBERT HEINECKEN, 1965**

2
Jerry N. Uelsmann
ROBERT HEINECKEN
1973, Gelatin silver print

With few exceptions, until the 1960s, photographic "art" on the West Coast was largely associated with a formal and naturalistic aesthetic as established by the *f*.64 group. The meditative and lyrical iconographic images of Edward Weston, Imogen Cunningham, and Ansel Adams, for example, represent a photographic vision that valued the qualities of visual clarity: sharp focus, attention to detail, full tonal range, a transparency of the medium, and the photographer's direct relationship with the subject. Photographers who identified with this vision perceived the photographic image as a site of truth, not necessarily of the documentary sort, but a truth about the power of sight and the beauty of nature. Robert Heinecken was not interested in this belief or aesthetic; from the earliest efforts his photographic work signaled a generational shift in West Coast art from an overarching concern with the "natural" to an obsession with the cultural.

From his initial experiments in photography, Heinecken's images implied a deep skepticism not only of the modernist photographic tradition, but also of how images are used in the culture at large. Heinecken showed no respect for the "purity" of the photographic process. In fact, he rarely even operated a camera. Image manipulation, appropriation, repetition, seriality, and graphic effect are the formal and stylistic characteristics of Heinecken's entire body of work. Sexuality, politics, self-referentiality, and humor are the consistent thematic threads that bind this materially varied body of work together. Heinecken understood that photographic imagery is the currency of consumption in modern society and that every exchange, whether it be economic or sexual or both, is influenced by the media imagery we have internalized and by which we are acculturated.

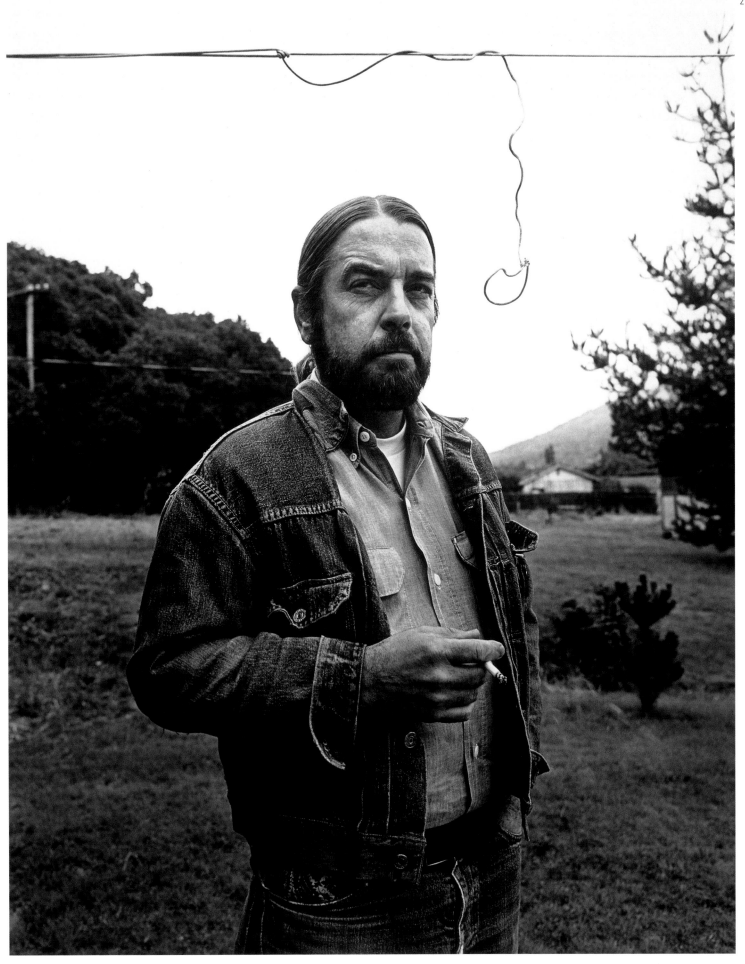

3

Heinecken's work was in many ways unprecedented in its emphasis on the materiality of photography. The commercial, journalistic, and pornographic images he employed as the basis for his work not only speak of his individual aesthetic sensibility, but concretely embody the times in which they were made. Living and working behind the iconostasis of the Hollywood image-making machine, he chose to hold up a mirror to the image industry itself by utilizing its most fragile refuse. Reframing cheap, pre-existing, prefabricated, and predigested images, Heinecken was able, by simple rejuxtaposition, to alter the meaning and reception of these images. In doing so he shifted the critical position of photographs vis-à-vis the modernist practices of "fine art photography." His early denial of the presumed technical and cultural transparency of the medium and his understanding that photography was more than an art practice but also a cultural phenomenon antici-pated the soon-to-be-ubiquitous postmodern sensibility.

Heinecken's prolific output, especially the magazine work of the 1960s and 1970s, represented a transference of significance between the original and the copy. In much of this work there is no presumed original, suggesting that we inhabit a world of incessantly mutating patterns, of signs that offer novelty but essentially remain the same in an endless recycling of surface. The locus of meaning turned away from the individual discretionary mode of private visions and toward the cultural manufacture of significance. Under the rotating klieg lights of Hollywood and the tyrannically blue skies of Southern California, Heinecken revived the twin spirits of Dada and Surrealism. By utilizing collage, montage, appropriation, and a perverse sense of humor, he sometimes critiqued, and other times reveled in the terrors and pleasures of image consumption. A full decade before Susan Sontag published her sociopolitical observations concerning the role photography plays in our private and public lives, Heinecken was making work that was fully aware that "photographs became part of the general furniture of the environment." [1]

For many of us who were students of art and photography in the 1970s, Robert Heinecken's work was influential on multiple levels. Young artists were interested in his photographic imagery not only in terms of process, but also in terms of how he conceived of photography in relation to the increasingly visual culture in which we lived. In his use of Polaroid instant prints, hand-coloring, magazine

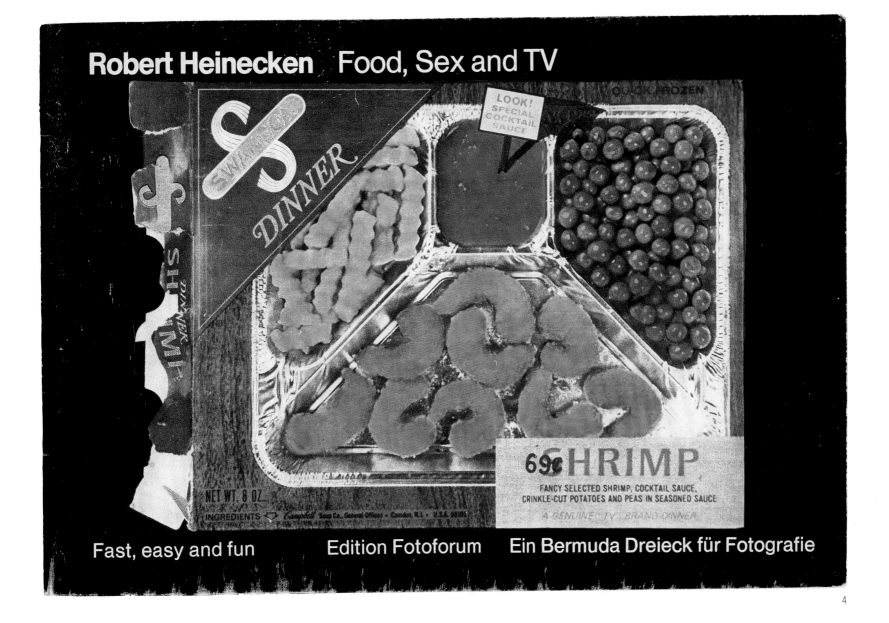

In this issue: Fenton, Uelsmann, Heinecken

5

PHOTOGRAPHY/INDEPENDENT FILM/VIDEO/VISUAL BOOKS

# AFTERIMAGE

A PUBLICATION OF THE VISUAL STUDIES WORKSHOP

## LATIN AMERICAN PHOTOGRAPHY

### F. HOLLAND DAY

### ROLAND BARTHES

### ROBERT HEINECKEN

REVIEWS: Horace Nicholls, Lewis Baltz/Park City, and more. NEWS: report from Los Angeles, Kodak/Polaroid patent lawsuit goes to court, artists' book conference planned in Philadelphia, grants announced by Film Fund, Crisis to Crisis, Annenberg School initiates media grant program.

6

ROBERT HEINECKEN: AN INTERVIEW —page 8

7

pages, sexual banter and jokes, he seemed wholly unconcerned with the preciousness of the "fine art print" and the limited repertoire of acceptable content. In Heinecken we found an artist who was not slave to the self-imposed rules of photographic modernism. This relative freedom was not only a function of Heinecken's iconoclastic nature, but also a result of living and working on the West Coast.

Compared with the fading influence of f.64, the imposing "straight" aesthetic of East Coast photographers, photohistorians, critics, and curators remained trenchant, espousing a practice firmly rooted in the discourse of the social document in which the photographer was positioned as a detached observer of "what's out there." The "hand of the photographer" was to remain hidden in service of retaining the sanctity of the one-to-one relationship between the photograph and the subject, between the signifier and the signified. Although some resonant echoes of this bifurcated regionalism (and the parochialism that it implies for photography) can still be heard, the wholesale absorption of photography into the larger art world in the 1980s makes this earlier dualism seem almost quaint.

Throughout the 1970s, one could barely turn the pages of a journal devoted to contemporary photography without coming across a reference, review, or essay devoted to Heinecken's work. His name and artwork had become synonymous with the irreverent and experimental spirit of the West Coast of the 1960s and 1970s. Despite this seemingly secure position in the history of photography, he

became *persona non grata* in much of the critical writing of following decades. It was the paradigmatic shift in photographic practice in the 1980s that paradoxically both obscured and highlighted Robert Heinecken's legacy. Abigail Solomon-Godeau, in her widely read and influential essay "Photography After Art Photography" published in *Art After Modernism* (1984), for example, does not mention Heinecken's name nor his significant contributions to media-oriented art. Her thesis on the difference between modernist and postmodernist art revolves around this observation:

Seriality and repetition, appropriation, intertextuality, simulation or pastiche: these are the primary devices employed by postmodernist artists.[2]

Heinecken had utilized most of these "devices" ten to twenty years before Solomon-Godeau's article was published. She illustrates her manifesto with the works of such artists as Richard Prince, Barbara Kruger, Cindy Sherman, and others as progenitors of media-oriented photography. In fact, the only mention of Heinecken's name in the entire anthology *Art After Modernism*, the "New Testament" of postmodernism, is in Martha Rosler's essay "Lookers, Buyers, Dealers and Makers: Thoughts On Audience," in which she takes a slap at "the pussy porn of Robert Heinecken."[3] The deliberate excising of Heinecken's legacy reminds me of the ex-husband or jailed uncle whose image has been razored out of the family portrait—a presence made all the more felt by its obvious absence.

The reasons for this historical deletion are many. Arguably the most relevant is that there was an important and significant generational shift in art at this time. This shift was accompanied by a renewed interest in the political content of art as it was informed by what was termed a "critique of representation." This left many artists of the previous generation feeling like fish out of water. Second, until very recently there has been an East Coast critical myopia regarding artwork created west of the Hudson River. A third reason is that the modernist ghetto of "fine art photography" proved to be separate and unequal in relation to the larger art world. For instance, while most photographers were preoccupied with making limited edition fine art portfolios, artists such as Andy Warhol were proving that the phenomenon of photography was far more interesting than the Zone System. Lastly and more specifically, the problematic sexual content of Heinecken's imagery led to a generation of accusations of sexism and misogyny.

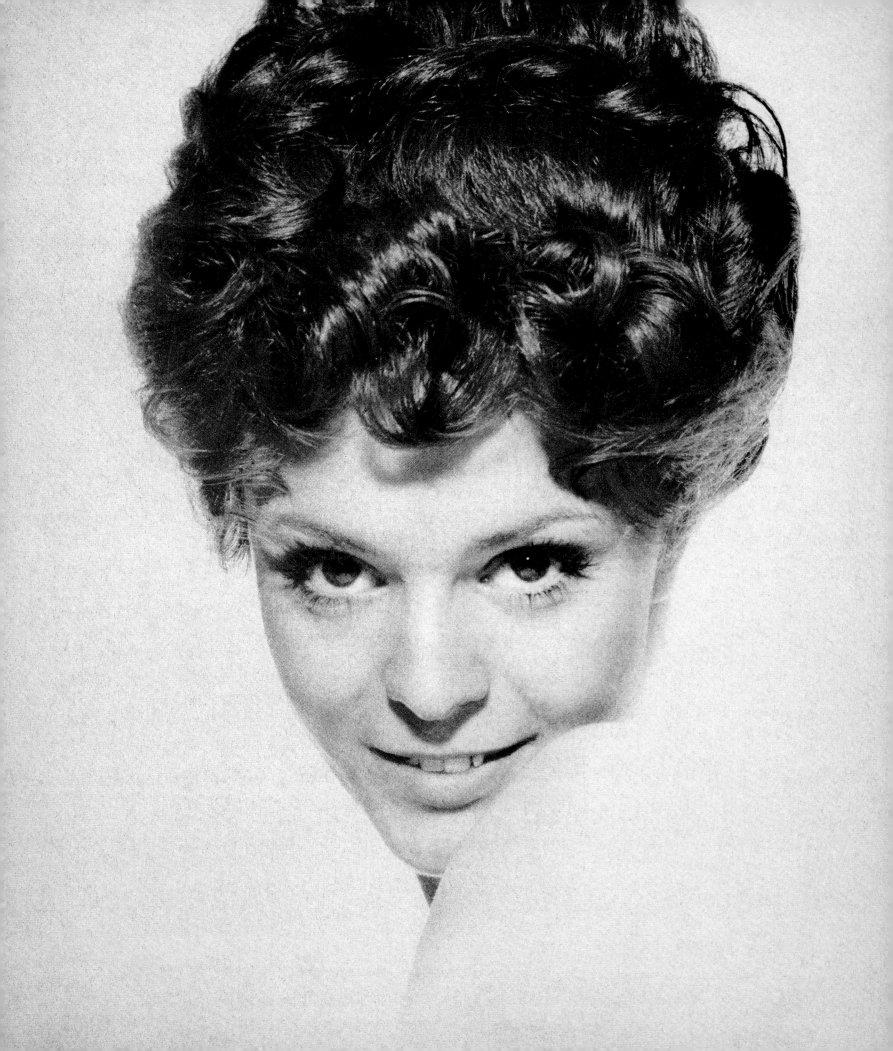

# Anecdotal Triptych I

**JOKES**

I was in love with my cousin Debbie, who was a year older than I and infinitely more mature. While the boys played "army," Debbie played the Red Cross nurse. Deliberately and continually I was cut down by "Kraut" gunfire so that Debbie would attend my wounds. I remember her sparkly brown eyes and her strangely soothing voice as she bent over me pretending to wrap bandages around my phantom gunshot wounds. ¶ One evening at a sleepover pajama party for all the cousins, the boys and girls were stuffed in sleeping bags giggling in the dark. Debbie lay beside me on the floor of the basement rec room. Forces that I did not understand compelled me to loudly recite my first dirty joke: One night in the jungle Tarzan and Jane are going to bed and are getting undressed. Jane takes off her shirt and Tarzan asks, "Jane, what are those round things?" Jane replies, "Oh, those are my headlights." Tarzan takes off his leopard skin, and Jane asks, "Tarzan, what's that between your legs?" "That's my snake," Tarzan tells her. Jane takes off her pants. Tarzan asks, "What's that between your legs?" and Jane says, "That's my jungle." So they lie down and go to sleep. In the middle of the night, Tarzan wakes up yelling, "Jane, Jane, turn on your headlights, my snake is crawling through your jungle." ¶ I had no idea what that joke meant, and trying to conceal my ignorance with noise, I laughed louder than any of the other kids. Little did I know that Debbie's mom, my Aunt Alice, was on her way downstairs to tuck us in. (I loved that she always said "good night, kitty cats.") She silently listened on the darkened stairway for the length of my performance. Aunt Alice was no tyrant. One at a time she tucked each of us in, and while leaning in to kiss me on the cheek, she whispered that I should tell my mother the joke and have a talk with her about it. An infusion of shame inexplicably filled me; I was flushed with hot confusion. I said nothing, but was sure that I had stumbled blindly and irrevocably across a forbidden border.

9 – 12
Test images for MADEMOISELLES
1970

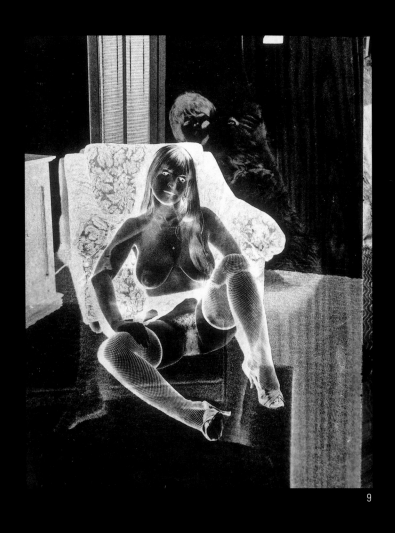

9

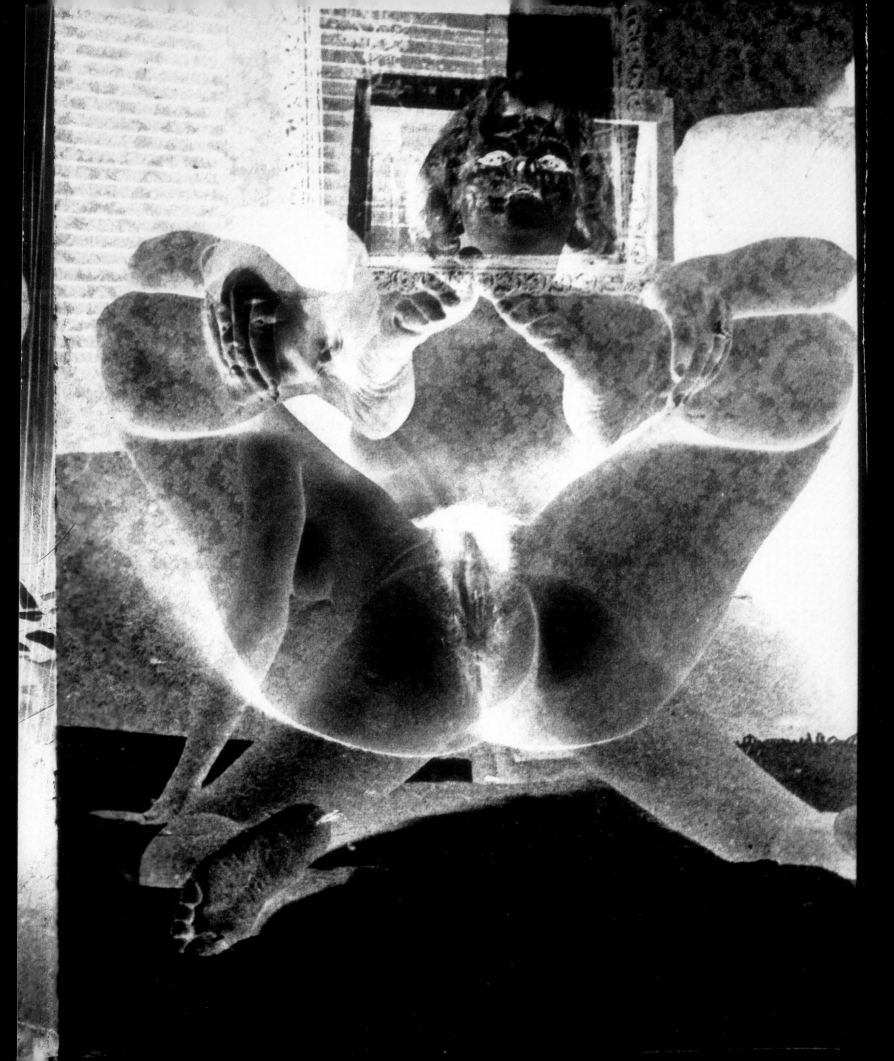

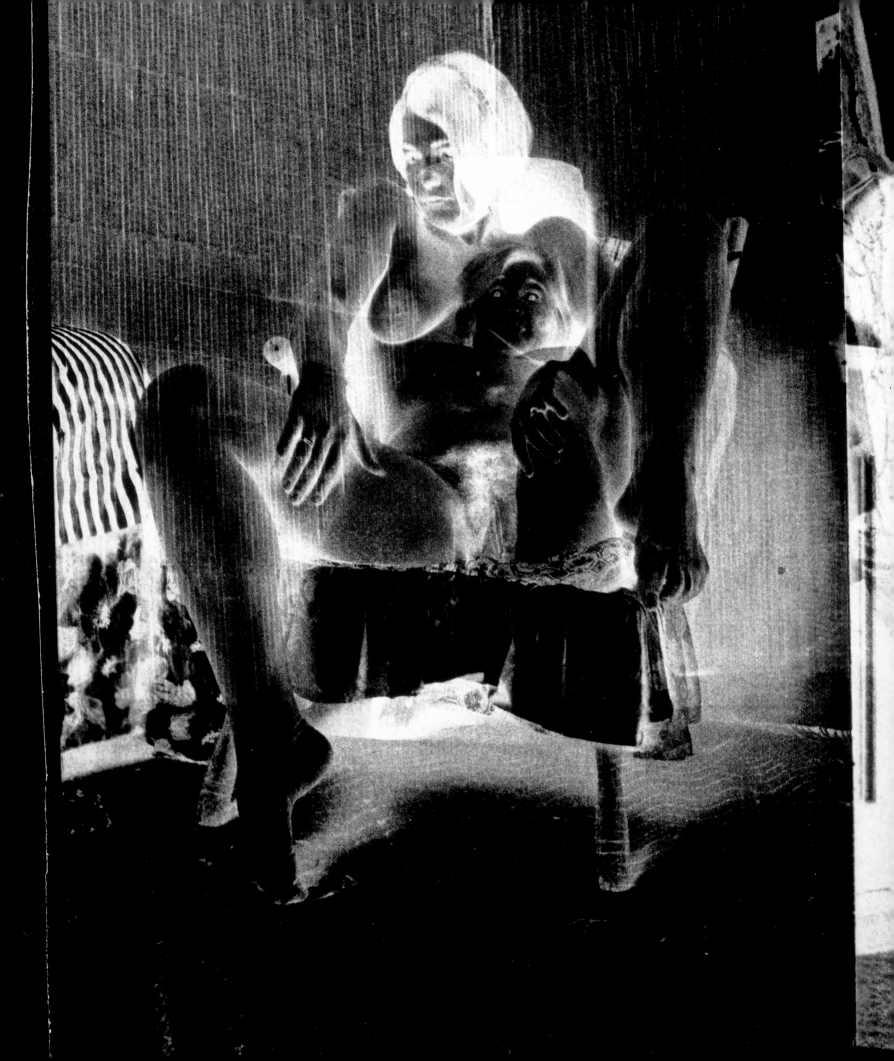

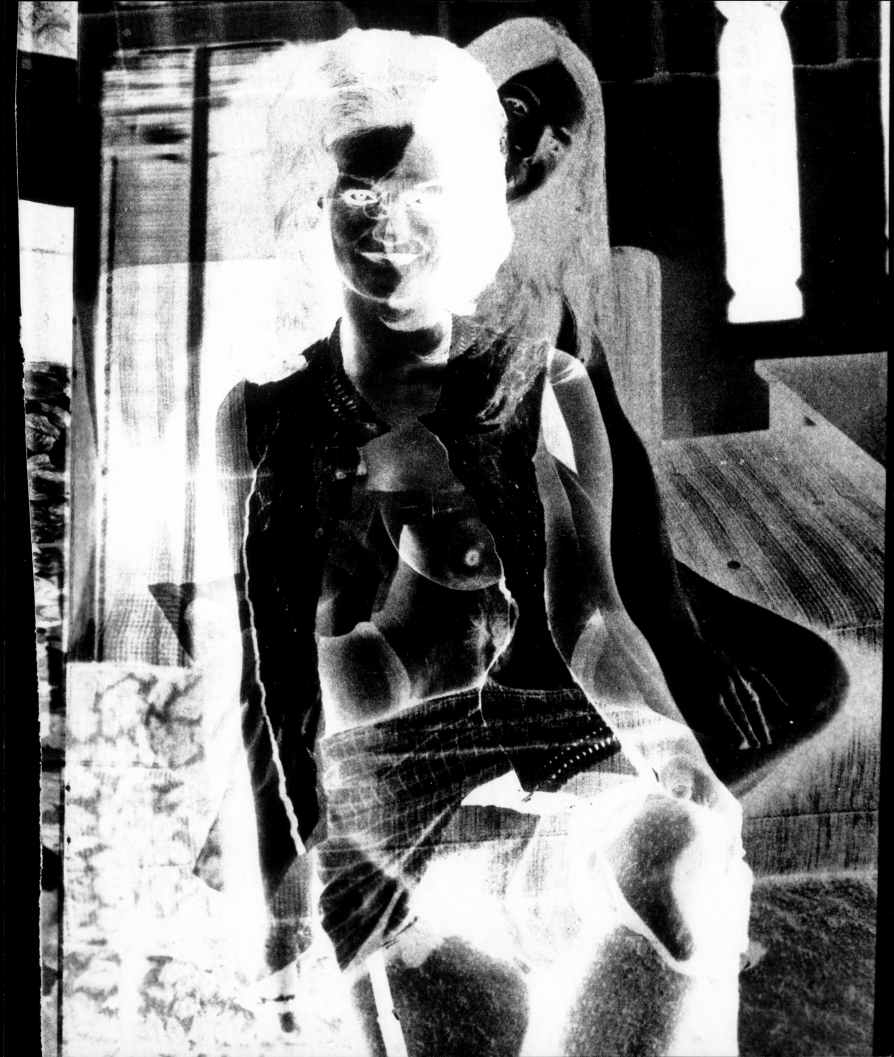

# BIOGRAPHICAL FRAGMENTS

## THE MAKING OF A RAT PACK SURREALIST

While spending time with the voluminous Robert Heinecken Archive at the Center for Creative Photography, I kept thinking about the problematic nature of some of his imagery and what an odd character he was in the art world. Although he played a pivotal role as a prolific artist and influential teacher, it was his particular version of maleness, and how this maleness manifested itself in his artwork, that eventually estranged him from many in the academic and critical communities. This generational model of maleness was formed in the heroic shadows of World War II. Heinecken was born in 1931, and although he was too young to fight in the war, he did serve in the military during the Cold War years as a Marine jet fighter pilot. Perhaps apocryphal is the story that, being too short to be a pilot, Heinecken carefully cut layers of magazine pages in the shape of his foot and inserted them into his boots so that he could add an inch or two to his stature and just clear the height requirement.

Among the many youthful artifacts in the archive is a boyhood scrapbook embossed with a fighter-bomber and surrounded by golden military symbols. Although it is not unusual for a boy to assemble such a compendium of interests, the pages of Heinecken's scrapbook exhibit strictly circumscribed content, with each page displaying a fastidious attention to precision cut-outs as if to predict his future artistic activities. Illustrations of military adventures with special emphasis on heroics in aviation—diving bombers, excited tail gunners, strafing jets, and a myriad of explosions—testify to the positive cultural image of the military during his formative years. Heinecken also toyed with cartooning: slouching G.I.s with stubbled faces and pointy-breasted starlets strutting in bathing suits are just two of the character types that populate Heinecken's youthful imagination and illustrate cultural tropes of male and female stereotypes in mid-century America.

Heinecken came of age after the moral dramas of the 1930s-1940s and before the fervor and flux of the 1960s. His formative years in the aftermath of World War II were marked by the ascendancy of television and of commodity excess; the simultaneous phenomena of loosening of sexual mores and strict gender roles; urbanity and its attendant ingredients of "sophistication." It was a period

13

14

Navy Air Cadets

15

Vega
Ventura

16

General Alarm

A-20-A Havoc

17

Detail, UCLA yearbook, portraits of Sigma Nu fraternity,
Heinecken top left, ca. 1959

18

THE EVOLUTION OF THE HAIR OF THE ARTIST AS AVIATOR
OR VARIATIONS ON THE FRONTAL POSE
1974, Gelatin silver prints and text on board, 34.3 x 45.7 cm
79:046:009/National Endowment for the Arts Museum Purchase, 1979

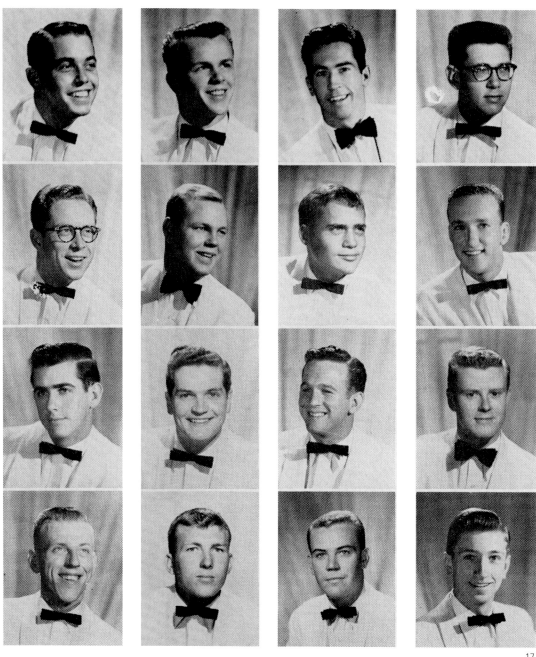

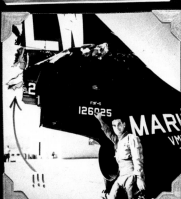

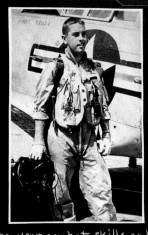
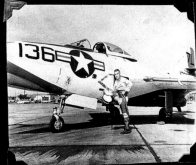

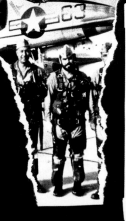

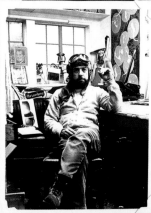

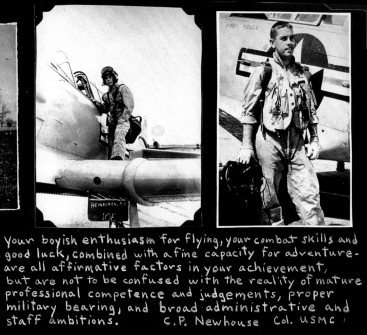

Your boyish enthusiasm for flying, your combat skills and good luck, combined with a fine capacity for adventure - are all affirmative factors in your achievement, but are not to be confused with the reality of mature professional competence and judgements, proper military bearing, and broad administrative and staff ambitions.        C.P. Newhouse   Col. USMC

The Evolution of the Hair of the Artist as Aviator  or  Variations on the Frontal Pose     Heinecken '74

18

19

20

21

of tremendous economic expansion characterized by the battling cultural forces of individualism and social conservatism. Had Heinecken lived in the suburbs, raised his family, and climbed the corporate ladder, retiring to playing golf, his model of maleness would seem "normal." But Heinecken wanted to be an artist. After discharge from the military, he studied art at UCLA where he majored in printmaking, receiving his MFA degree in 1960. At UCLA, Heinecken "stumbled into photography" with no formal training as a photographer as such:

I was never in a school situation where someone said, 'This is the way a photograph is supposed to look.' I was completely open to cut them up, or do anything like that. I think if I had been in touch with people earlier, then I wouldn't have felt comfortable doing that. It would have been too bizarre. [4]

Most photographers are interested in the act of observation, of being in the existential moment (and the actual physical site) when the shutter is released. Artists who come to photography from another medium—Andy Warhol, Robert Rauschenberg and John Baldessari, for example—are often more interested in the "image" than they are in the hardware or what it means to be a photographer. Coming to photography from printmaking, in which image manipulation is a given, as opposed to the windowlike purity of traditional photography, Heinecken possessed the relative freedom to treat his adopted medium with a kind of physicality that was seldom seen among photographers.

19 – 22
Untitled drawings, ca. 1946 -1949

23
Untitled drawing, ca. 1939

23

Robert Heinecken was in the right place at the right time—the art department at UCLA needed someone to teach the newly instituted photography classes and he was hired for a position he would hold for the next thirty years. Having never formally studied photography, he became one of the most influential teachers in the medium and in the process helped to establish UCLA as one of the country's leading art programs.

Heinecken's career as an artist and teacher has spanned four decades of enormous cultural change and, in his art and persona, he has fused apparently irreconcilable cultural attitudes. Temperamentally, he seems to embody a "Rat Pack" sensibility. One can easily imagine Heinecken pouring cocktails for his pals Frank, Dean, and Sammy, proclaiming "How sweet it is!" after the first sip of a dry martini. Yet as the 1960s wore on and Heinecken's hair grew in, he became a guru, an eccentric and influential teacher and mentor to generations of photographic artists. His archive is filled with letters of gratitude, testimonials, and gifts of art from former students. He was energetically involved in the Society for Photographic Education in its founding years, helping establish an important academic and professional organization for photographers, artists, critics, and historians. He was a peculiar hybrid who straddled often contradictory social and aesthetic impulses: a former Marine; a 1950s family man; a wanna-be member of the "Rat Pack"; a bearded, long-haired experimental artist; a highly regarded academic; and a modern-day Surrealist in cowboy boots.

In the important exhibition and accompanying catalog *Proof: Los Angeles Art and the Photograph, 1960 to 1980*, Charles Desmarais maps the material and conceptual foundations for the change from the modernist view of the photograph as essential truth to the postmodernist concern with the cultural production of meaning. Desmarais claims that Southern California artists working with photography "anticipated current concerns by using the photograph as a basic tool for examining our culture's self-image." He adds:

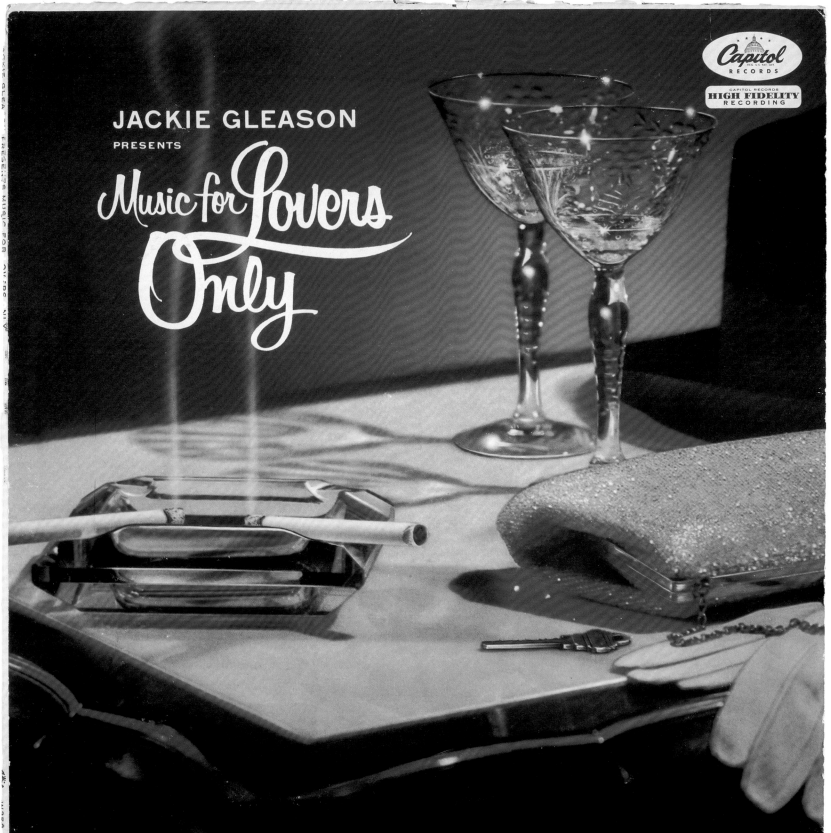

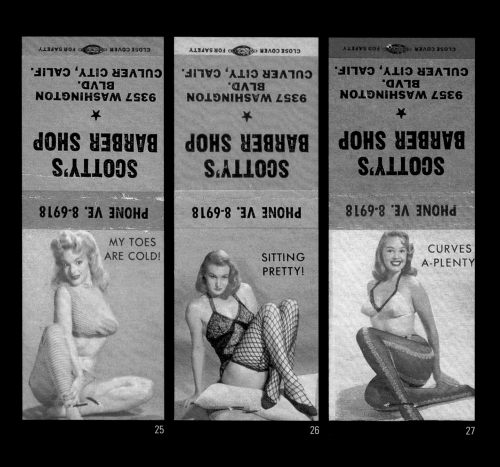

25

26

27

In emphasizing the materiality of the photograph, denying its transparency as a window to the world, Heinecken and the others were questioning its authority—its claim to Kramer's so-called "standards of purity and truth." To make work of this sort in the 1960s was an inherently political act, entirely in keeping with the social and political questions many of the works themselves raised with their images of commercial excess, political satire and sexual freedom.[5]

Until relatively recently, Los Angeles lacked a critical and institutional infrastructure to either support or police the activities of artists. No system of rewards and punishments—galleries, dealers, museums, reviews, patronage, and so on—was in place through which, either by design or by default, a local aesthetic could be cultivated. In the 1950s and 1960s, artists in Southern California found themselves uniquely situated, geographically and culturally isolated in a desert metropolis irrigated by a flood of images produced by the entertainment industry. This led to an organic diversity in approaches to artmaking; artists as diverse as Eleanor Antin, Ed Ruscha, John Baldessari, Ed Kienholz, Kenneth Anger, Wallace Berman, Llyn Foulkes, Edmund Teske, and Robert Heinecken all emerged in these years. Eleanor Antin describes the period this way:

[There was] an openness not found on the East Coast and a generosity of spirit. New York was always formulating the correct ways to work and think while back here we were always eager to be surprised and engaged in new ways.[6]

Thomas Crow echoes these sentiments in his book *The Rise of the Sixties:*

California artists, largely excluded from participation in any real art economy, were regularly drawn to the cheap disposability of collage and assemblage…recycling the discards of postwar affluence into defiantly deviant reconfigurations.[7]

It is ironic that in this relatively unsupportive environment, Marcel Duchamp had his first retrospective exhibition in the United States at the Pasadena Museum of Art in 1963. Coincidentally during this same period, Andy Warhol was having his first solo exhibitions at the Ferus Gallery in Los Angeles. Not to make an easy equation between these exhibitions and Heinecken's developing sensibility, but it seems significant that Duchamp's cerebral and irreverent legacy should bump into Warhol's seminal pop appropriations on the aesthetically unregulated territory of the L.A. art world. This synchronistic collision could only have helped to catalyze the nascent anarchic spirit that was incubating in Southern California.

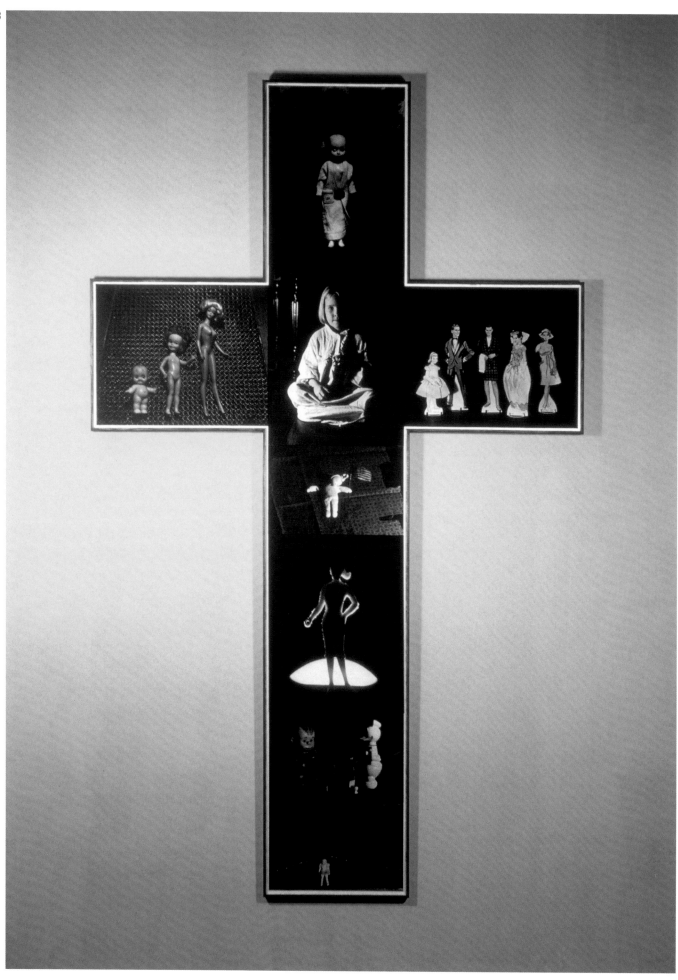

# IN THE ARCHIVE

## EARLY SKETCHES FOR GUYS AND DOLLS

As is evidenced by the contents of the archive, the early 1960s were a period of visual exploration for Robert Heinecken. The work from these years does not coalesce into a coherent aesthetic, but one can feel a sensibility forming. The seeds of later ideas were being sown, prototypes of constructed images were being assembled, and strategies such as projecting images on models' bodies reveal open experimentation as well as the power relationships at play in the studio. Art ideas are seldom the invention of a single artist; new approaches, concepts, and materials seem to float in the cultural ether, waiting for artists to seize the opportunity to make them concrete. In New York, Warhol, Rauschenberg, and Lichtenstein were just a few of the many artists who were mining popular culture for images and materials. In Los Angeles, Wallace Berman, Ed Ruscha, Llyn Foulkes, and George Herms were some contemporaries of Heinecken who were experimenting with photographic images in nontraditional contexts, including collage, appropriation, and the conceptual use of language in relation to images.

The years 1964-65 appear to be a crucial period for Heinecken. He began work on the seminal *Are You Rea* and a number of other pieces which exhibit the sculptural, conceptual, and sexual concerns that later came to identify his work. *Visual Poem About the Sexual Education of an American Girl* (1965), a cruciform photo-sculpture measuring eight by five feet and consisting of seven separate photographs, is probably the least known and the most provocative. It is an ambitious piece both in form and in content. The scale and unusual shape predates the "Big Picture" artists of the 1980s such as Gilbert and George by almost two decades. Heinecken's use of dolls and cheap plastic figures as theatrical characters also prefigures defining 1980s works by artists such as David Levinthal, Ellen Brooks, and Laurie Simmons.

28

VISUAL POEM/ ABOUT THE SEXUAL EDUCATION
OF AN AMERICAN GIRL
1965, Gelatin silver prints (reproduced from reference slide)

29

DOLL WITH READY HAND
1965, Gelatin silver print (reproduced from reference slide)

30

TOY PROSTITUTE
1965, Gelatin silver print (reproduced from reference slide)

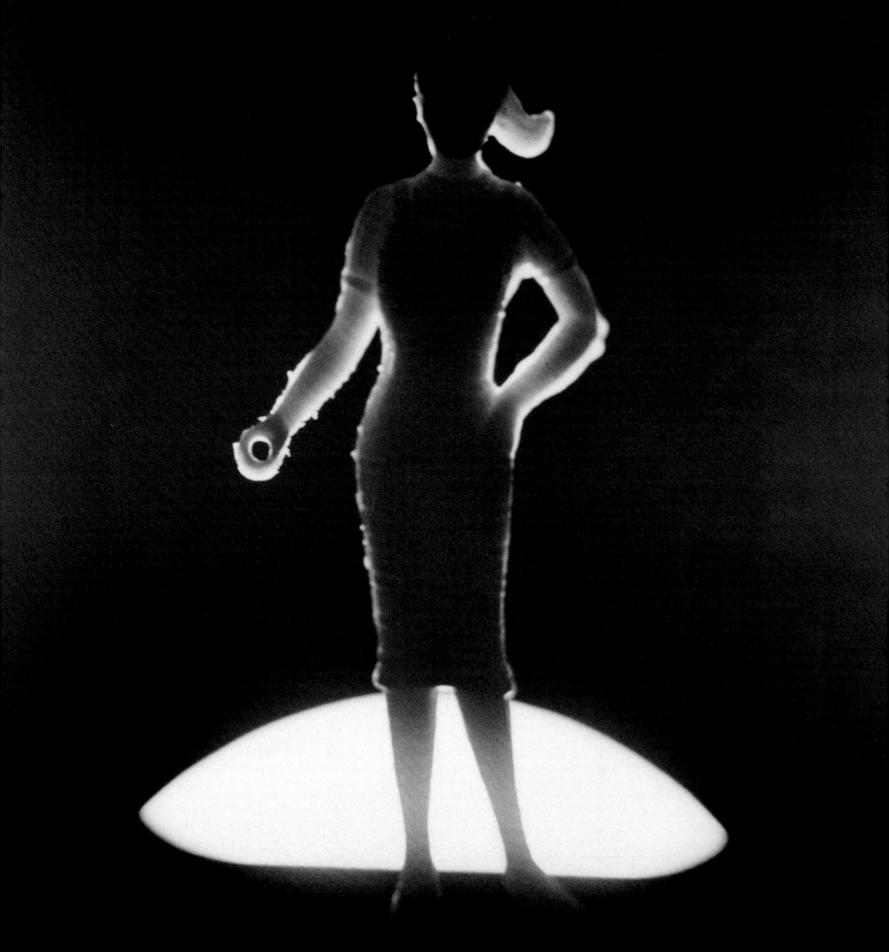

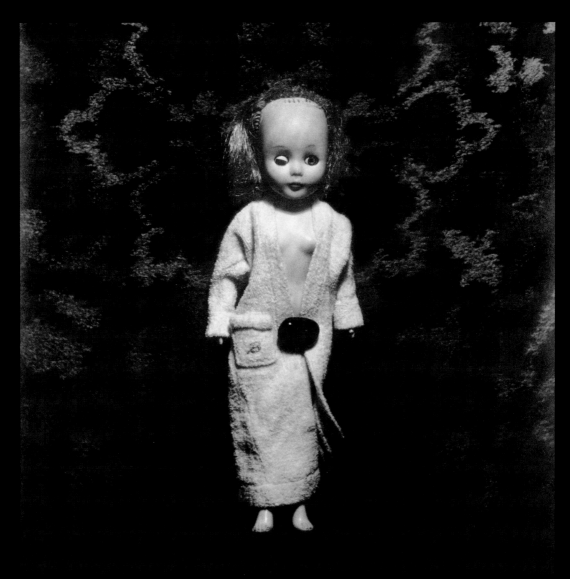

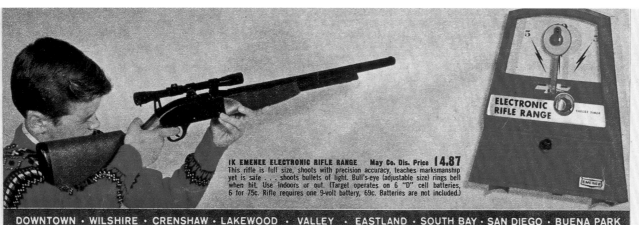

CHILD GUIDANCE TOYS

**IK EMENEE ELECTRONIC RIFLE RANGE** May Co. Dis. Price **14.87**
This rifle is full size, shoots with precision accuracy, teaches marksmanship yet is safe . . . shoots bullets of light. Bull's-eye (adjustable size) rings bell when hit. Use indoors or out. (Target operates on 6 "D" cell batteries, 6 for 75c. Rifle requires one 9-volt battery, 69c. Batteries are not included.)

ELECTRONIC RIFLE RANGE

**IH JFK IN ROCKING CHAIR**
Replica of JFK in his rocking chair reading his favorite newspaper. Plays "Happy Days are Here Again" as he rocks and reads. Operates on 2 batteries (not included) 2/25c.
May Co. Discount Price____ **6.87**

DOWNTOWN · WILSHIRE · CRENSHAW · LAKEWOOD · VALLEY · EASTLAND · SOUTH BAY · SAN DIEGO · BUENA PARK

The piece shows a young girl sitting at the crossroads of culturally constructed versions of femaleness. Floating above her is an image of a ravaged plastic doll that has seen better days. The doll's hairline seems to have been gnawed at, and one eye is half-shut, making her face appear physically abused. Surrounding images present less violent but no less pessimistic imagery. Immediately below the young girl, a cloth doll droops while holding onto an American flag. Below this sad gesture of patriotism is a dramatically backlit plastic figure whose hand is eternally fixed in position to "service" any needy male. Other images suggest primitive taxonomic studies of male/female representations. Although his sardonic wit is ever present, as with much of Heinecken's work of later years, it is difficult to discern whether he is decrying the burdens of sexism or merely using the pictorial drama of its symbolism to enhance the weight and theatricality of his own work.

Another image from 1965, in which the words "Then people forget you" are projected onto a woman's bare torso, provokes similar questions about Heinecken's intentions. The ambiguity (or confusion) of its meaning arises from the mixed message of whether there is a sympathetic undercurrent hiding in the aggressiveness of the declaration. We wonder who is speaking, who is the "you," and who are the "people." Is the image referencing one who feels used sexually? Or is it a more general statement about disappointment and vulnerability? Or perhaps it is intended to be far more enigmatic than that. Although every art object need not have a literal meaning, Heinecken's work often begs the question because of the loaded subject matter of his images. This early in his career we can see his use and growing reliance upon culturally loaded signifiers: images, symbols, and texts that by design or by default cannot help but provoke overdetermined readings.

*Child Guidance Toys* (1965) is less immediately problematic in terms of its gender politics as it obviously satirizes the acculturation of boys in the use of guns. The images are from an advertising supplement in the *Los Angeles Times*, November 24, 1963, only two days after John F. Kennedy's assassination. Obviously the advertisement was designed and printed long before that fateful day in Dallas. Heinecken does not play up the commercial foretelling of that tragedy. Instead he makes a more general statement by the simple juxtaposition that transforms the boy next door into JFK's assassin, as if to imply that society itself blindly rears its boys to be murderers. Although the message is not novel, it is the quirky commercial and historical specificity that keeps the image compelling to this day. The advertisement plays on the assumed natural innocence of children, yet it remains a creepy reminder of just how deep is the social training of boys to weapons. *Child Guidance Toys* is on one level a straightforward commentary on youth violence. More perversely, it is a farcical reenactment of November 22, 1963, in which American boys can assume the role of Lee Harvey Oswald by blowing the brains out of the smiling president as he rocks to the tune of "Happy Days Are Here Again."

**ARE YOU REA #1**
1966, from the portfolio *Are You Rea, 1964-1968*
Offset lithograph, 27.4 x 20.0 cm
91:014:003/Purchase

# ARE YOU REA

**1964-1968**

Maybe what's interesting to me is finding existing relationships that haven't been seen before…. Magazines are really interesting that way, because they're so commercial, so much wanting to indicate the way you should behave, through the ads and the writing and all that—they're a surrogate religion, in a way.[8]

*Are You Rea* is perhaps Heinecken's most important body of work. In its clarity, its gritty elegance, and its ripple effect on photographic practice as an art form, this group of pictures was uniquely influential. Thinking like a printmaker and media critic, as if Dürer met McLuhan, Heinecken issued a portfolio of images derived from magazine page photograms in 1968. The portfolio included twenty-five reproductions and was accompanied by two texts, one his own and another from *Les Vases Communicants* by Surrealist André Breton, who declares:

It will in the end, be admitted that everything, in effect *is an image* and that the least object which has no symbolic role assigned to it is capable of standing for absolutely anything.[9]

Heinecken's more understated manifesto, the first widely distributed artist's statement on his processes and concepts, reads in part:

These photographic pictures are a result of my interest in the multiplicity of meanings inherent in aleatory ideas and images….The printed material from which these pictures are made has not been manipulated or placed into superimposition. These images existed simultaneously on the front and back of individual magazine and newspaper pages, and are reproduced directly.[10]

He concludes:

The selection of the pages is based upon my assumption that they are visually stimulating and that they seem to reveal ironic or significant cultural conditions, much in the same way that some contemporary documentary photographers are doing. The distinction may be drawn, however, that these pictures do not represent firsthand experiences, but are related to the perhaps more socially important manufactured experiences which are being created daily by the mass media.[11]

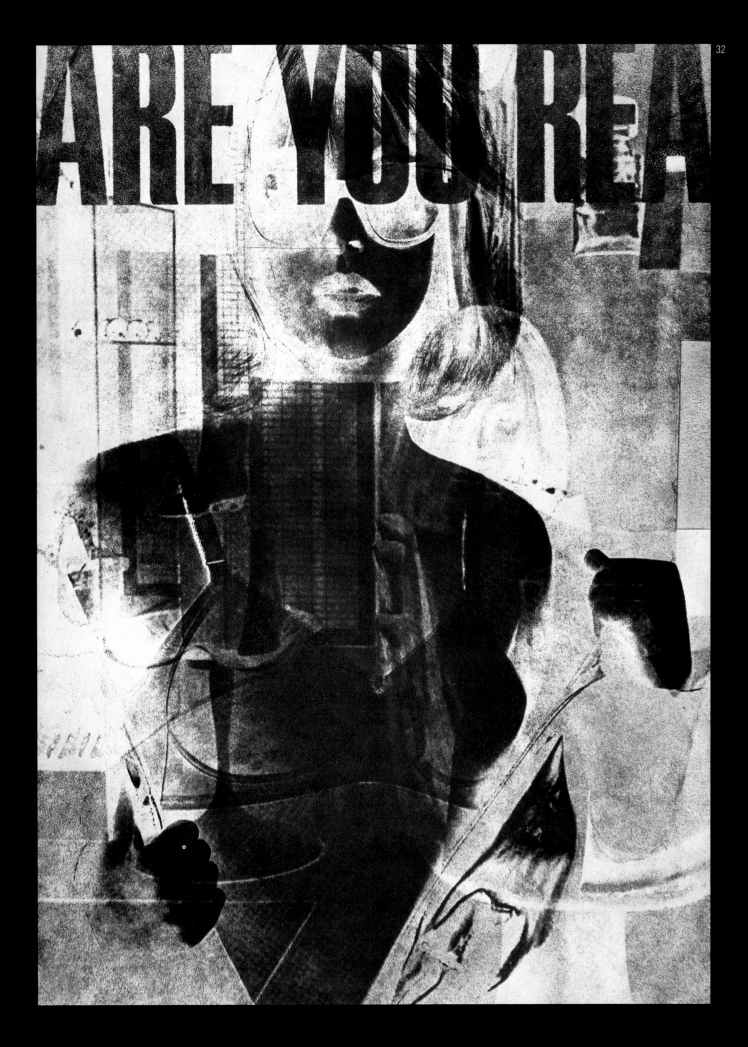

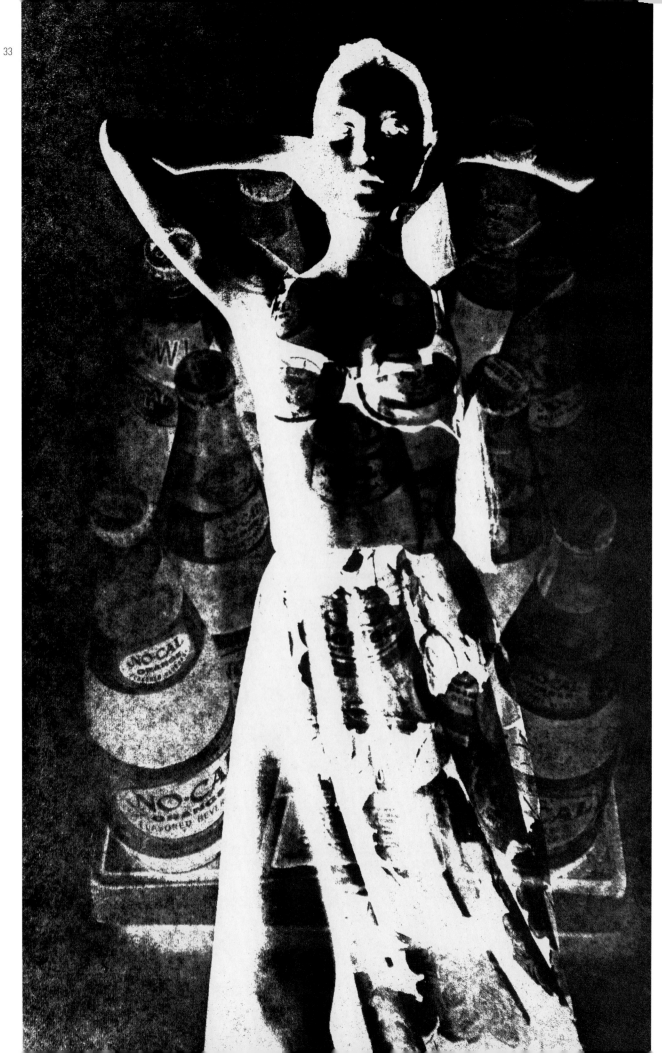

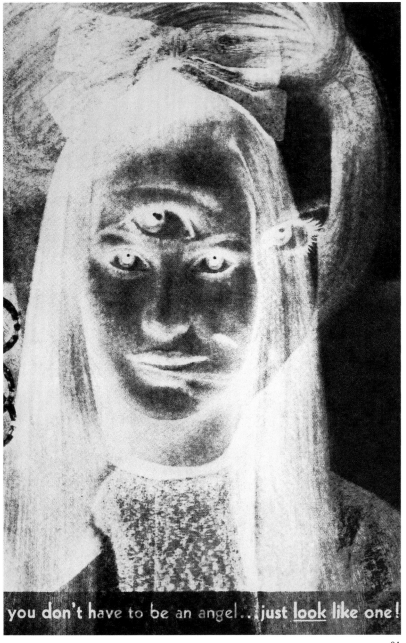

34

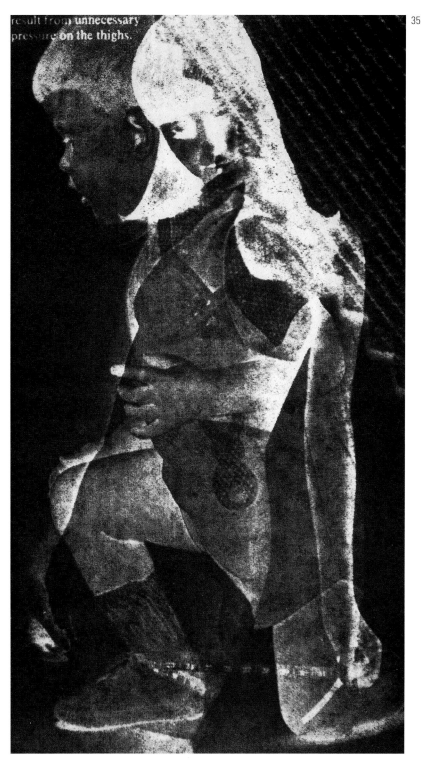

35

This portfolio marked Heinecken's emergence as an artist and thinker of some consequence; as early as the mid-1960s, he adopted a pivotal role in shifting the discourse about photography from cameras, tonalities, and traditional social documents to alternative applications of the medium. He declared his interest in "the multiplicity of meanings" in chance juxtapositions. In doing so, Heinecken suggested that it is not only the artist who creates meaning, but that context and random association also play an important role in the effect of imagery upon our conscious and unconscious perceptions. By isolating and reframing these subliminal and/or synchronistic image encounters found among magazine pages, *Are You Rea* uncovered social documents of a different order.

His use of the phrase "visually stimulating" seems a little corny to contemporary ears, but this is immediately followed by the almost unprecedented statement (by a photographer, anyway) that these images are similar to documentary photographs. At this time, there were few photographers, curators, photohistorians, or critics whose concept of the medium would allow for such a broad interpretation of what constituted a documentary image. Heinecken claims that although the images from *Are You Rea* do not represent "firsthand experiences," they were nonetheless important and are, in some fundamental manner, "documents" of the time in which he lived. It is now common to recognize how we are acculturated by images in terms of gender, beauty, race, and class. At the time, Heinecken's position that these "manufactured experiences" might have more impact on the individual and culture than relatively inaccessible art images was as rare as it was prescient.

The images in this portfolio were formed by passing light onto photographic paper through a page torn from a magazine. Both sides of the page leave an impression on the light-sensitive emulsion, each side sometimes enhancing, sometimes canceling out the shapes and legibility of the reverse side. The subsequent chemical processing is normal; these images are not made by sandwiching negatives or any other darkroom trick. The photographs are "negative" because the magazine image is a "positive." The title Are You Rea is in itself both interrogative and fragmentary, as if to suggest that even the rhetorical foundation of advertising is not all that it appears to be. The title also begs the question: Who is asking?

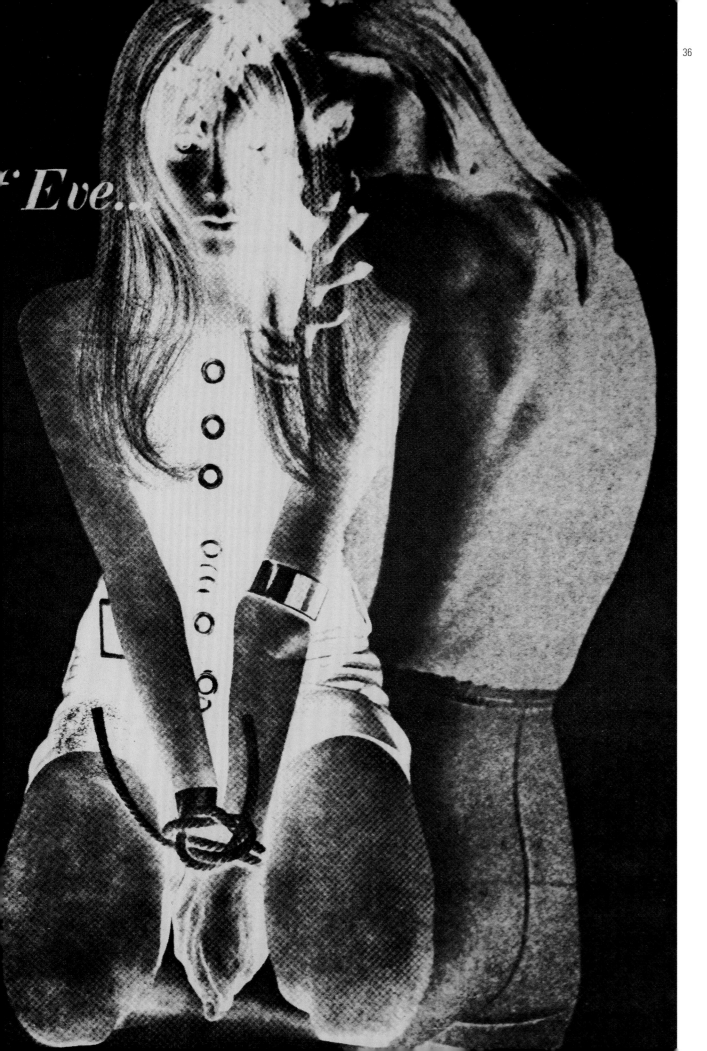

*Eve...*

**Zenith Handcrafted Color TV is so easy to tune you can do it blindfolded.** Zenith AFC (Automatic Fine-tuning Control) lets you tune the sharpest color picture at the flick of a finger. Just flick the AFC switch, and instantly, electronically, it tunes the color picture . . . and keeps it tuned . . . as you change from channel to channel. And it even perfects your fine-tuning on UHF channels . . . automatically.

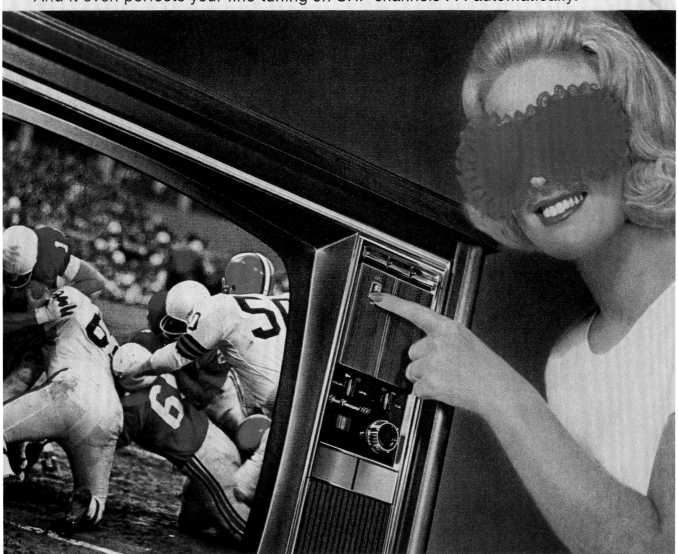

BEST YEAR YET TO GET THE BEST

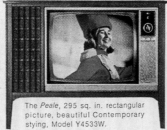

The *Peale*, 295 sq. in. rectangular picture, beautiful Contemporary styling, Model Y4533W.

The quality goes in before the name goes on

Who is the "you" here? Fifteen years before Barbara Kruger explored the inquisitive uses of gendered and neutral pronouns in her feminist photo-texts, Heinecken implied a question with both existentialist and postmodernist implications: Who (or what) do you think you are?

Every image in the portfolio is a play of transparency and obfuscation, of attraction and repulsion, of apparent accessibility and remoteness—in other words, the graphic and psychological machinations of advertising. Reflecting the content of the majority of magazine pages and of his own obsessions and sexual preoccupations, Heinecken's images are populated by female bodies and faces. These bodies mutate into multi-limbed figures, Kali-like creators and destroyers who are branded and tattooed by product names and logos. The gritty tonalities of these negative images suggest something satanic or occult-like in the iconography of pop culture: Charles Manson as graphic designer. Behind dark and diaphanous veils of imagery, the flesh dissolves into a hallucinogenic bestiary, bodies overlapping in frozen moments of graphic slippage.

The images of *Are You Rea* describe a parallel world of bodies and commodities, familiar but somehow alien, and hark back to the Surrealist strategy of "defamiliarization." This portfolio presents a psychedelically heightened Madison Avenue ad campaign, filled with exaggerated and culturally regurgitated symbols and motifs, unmasking the malevolent underbelly of commercialism. The cheap pulp fictions of these magazine pages are concrete artifacts of 1960s America. Millions of eyes gazed upon these very same images—comparing, contrasting, dismissing, internalizing, envying, or ignoring—caught, momentarily at least, in the seductive pull of image/commodities. The pictures themselves ask us if we are real, as if these imitations of life could arrogantly question our very authenticity. Illusion is an aspect of every society and it is the specificity of these American illusions that make them material history. In this way, the ghostly two-sided reproductions of *Are You Rea* resemble documentary images.

37
Magazine advertisement for
Zenith television, 1968

## Anecdotal Triptych II

**CENTERFOLDS**

My family was renting the first floor of a two-family house. The landlord (he had only two fingers and a thumb on his right hand, but that's another story) and his family lived above us. His two adolescent boys ruled over the game-room-turned-teenage-clubhouse in the basement. Flimsy wood paneling covered the damp concrete walls, folding metal chairs circled the Formica table. Adjacent to the hi-fi were bookshelves filled with magazines and LPs. This room was off limits to my brothers and me, although our games often had us scampering across the threshold on a dare, and because that room was forbidden territory, I was compelled to explore its secrets when no one else was around. ¶ Semi-consciously I was looking for sex, motivated by the power of my near-approaching adolescent future. My reconnaissance led me to a locked metal box. For days I attempted to locate the key, until I finally found the talismanic object taped under one of the bookshelves. I strained to hear any approaching footfalls above the thunderous pounding of my heart, the blood flow loudly gushing by my eardrums. Opening the box like a shy pirate, my eyes fell upon a stack of Playboy magazines. I quickly leafed through the pages of several issues but it was too much for me to bear alone. Later that afternoon I escorted two of my friends to the basement to reveal and share the array of exposed breasts. After what seemed to be an endless perusal of the pages, we each chose our favorite centerfold. Our choice became our private goddess; the others could make no claim to her. There was no discussion, no comparisons, no competition, no put-downs or attempts to humiliate. ¶ We carefully pried open the staples of the magazines to free our sacred icons. Trying not to wrinkle or bend the glossy paper, we slid the images under our shirts, so that "she" might kiss the skin of our torso. Then we escaped to the outside world, retreating behind a neighbor's garage where we could not be observed. After delicately removing our images from under our shirts, a small incision allowed us to slide the pictures behind the wire mesh in front of the garage window. The windowsill became pedestal and frame for our goddesses. The gridded wire fragmented the airbrushed bodies into regular patterns of delight, like stacks of heavenly candy we would never be allowed to taste. I will admit that I was not yet aware of the pleasures of self-stimulation and neither, I think, were my friends. Silently we stood there, hands thrust deeply into the dark warmth of our pockets, separate yet connected, each of us in our own hypnotic state, suspended in time, entranced by an image. —MAD

**DUOPHONIC** _ FOR **STEREO** PHONOGRAPHS

DT 5053

## Original Motion Picture Score

Recorded for this album by
THE SLOOPYS, THE MAD DOCTORS,
TERRY STAFFORD, PAUL & THE PACK,
THE CANDLES and BOBBY LILE

AMERICAN INTERNATIONAL presents

## DR. GOLDFOOT & THE GIRL BOMBS

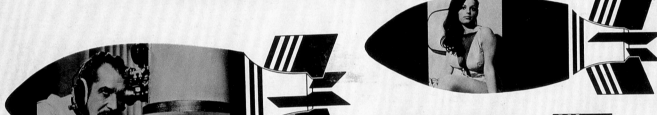

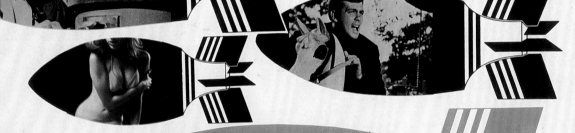

Starring

VINCENT PRICE
'FABIAN' · FRANCO AND CICCIO
LAURA ANTONELLI

Directed by MARIO BAVA · Screenplay by LOUIS M. HEYWARD and ROBERT KAUFMAN
Story by JAMES HARTFORD · Produced by FULVIO LUCISANO and LOUIS M. HEYWARD
IN TECHNICOLOR®

## SEX BOMB BABY YEAH!

By confusing distinctions between what constitutes eroticism versus pornography versus beauty versus banality—that's all one continuum. It is an interesting source, and I do feel that the most highly developed sensibility I have is sexual, as opposed to intellectual or emotional, and I think it's a matter of understanding that and using that and accepting that and not trying to alter myself.[12]

As a cultural artifact born of the 1950s, Hugh Hefner's *Playboy* was targeted and designed for guys like Heinecken. Appealing to self-described "sophisticated males," *Playboy* presented mildly risqué but perfectly tame airbrushed images of young women. The pages that bracketed the unblemished bodies featured interviews with public figures and articles about politics, and were filled with sexual cartoons, jokes, and advertisements for name-brand alcoholic beverages. *Playboy* sold (and sells) the image of a relatively hairless, unthreatening woman: the big-breasted girl next door. The magazine became a kind of how-to guide for many white middle-class men in 1950s America in which alcohol, sex, and cigarettes were the fuel for the nudge-nudge, wink-wink of witty detachment and other desired qualities of postwar heterosexuality.

One of the fundamental characteristics of Surrealism, especially as it manifested in photography, was the attempt to make the familiar appear strange and unknowable. This was especially true in images of the body—more often than not, the female body. Through distorting lenses, extreme close-ups, high-contrast tonalities, odd perspectives, and collage, the body was rearranged and represented as an icon of terrible beauty: foreign, erotic, and dangerous. Man Ray's and Hans Bellmer's reconfigurations of the female body served different personal functions; for Man Ray perhaps it was fashionably experimental, whereas for Bellmer it was a psychological obsession. Whatever the failures of the *révolution surréaliste*, the work of this period remains powerful for innumerable reasons, among them the radical revisualization of what might be termed the "internal landscapes" of desire (at least the hetero-male version).

39
*Doctor Goldfoot and the Girl Bombs*
(record album jacket), 1960s
Private collection

40 – 41
Untitled photograms derived from
*Treasure Chest* magazine images,
ca. 1969

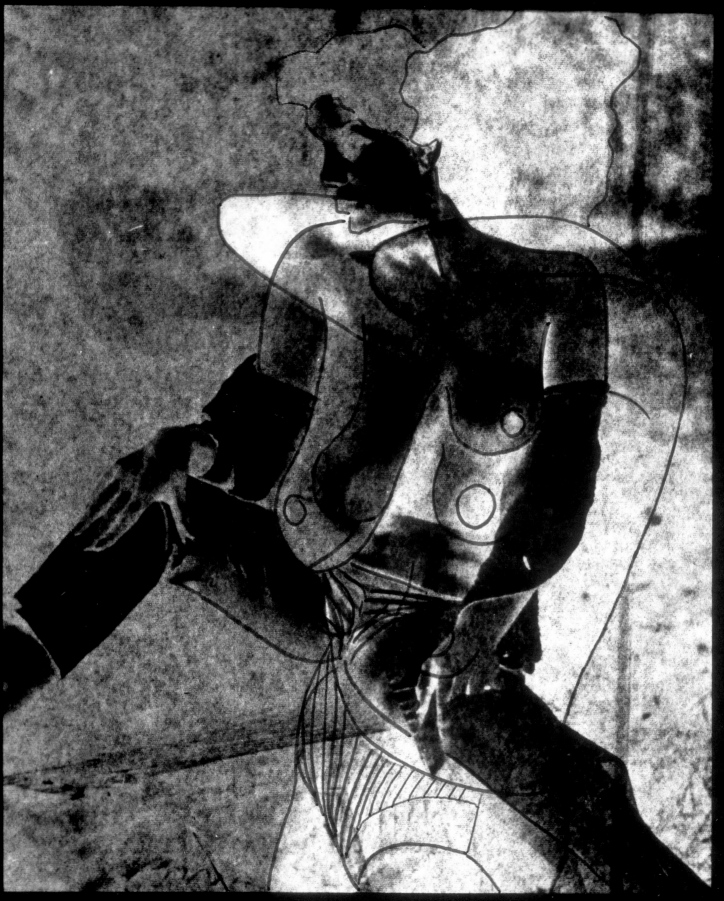

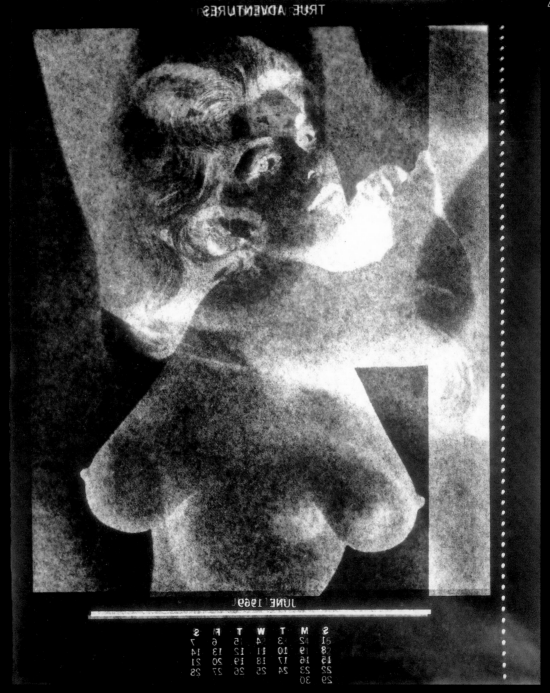

JUNE 1969

| S | M | T | W | T | F | S |
|---|---|---|---|---|---|---|
| 1 | 2 | 3 | 4 | 5 | 6 | 7 |
| 8 | 9 | 10 | 11 | 12 | 13 | 14 |
| 15 | 16 | 17 | 18 | 19 | 20 | 21 |
| 22 | 23 | 24 | 25 | 26 | 27 | 28 |
| 29 | 30 | | | | | |

Heinecken attempted to extend this enterprise, updating it for the "Swinging Sixties," dovetailing "Rat Pack Surrealism" with the sexual liberation of the late 1960s and early 1970s. Works such as *Five Figures in Vertical Hold* (1969), *Fourteen of Fifteen Buffalo Ladies* (1969), and *Erogenous Zone System Exercise* (1972) utilize pornographic imagery as the basis for trippy transformations of the erotic. Heinecken's strategies of defamiliarization included printing through magazine pages and various other printmaking processes to add layers of outline and color which heightened or obscured formal and sexual aspects of appropriated bodies. Heinecken's reconfigurations of the female body using store-bought porn are interesting insofar as he continues to mine pre-existing imagery for the sources of his work. But rather than challenging or subverting cliché sexual images, this work merely adds a patina of formal experimentation over what increasingly seemed to be a personal obsession with this kind of imagery. Heinecken himself seems to have a sneaking awareness of this problem in his 1976 interview with Charles Hagen in *Afterimage*:

That's how the magazines can be used, rather than as works of art. They're really needles. Or those porn pictures, they often make people very uncomfortable. They don't know whether to laugh or whether they should even be looking at them. And in the long run, it's not my business to really worry about it, but maybe it'll be those ideas that will be more important than these rather self-indulgent perversion pictures. I mean, they may be a fantasy of my own, a misplacement of value.[13]

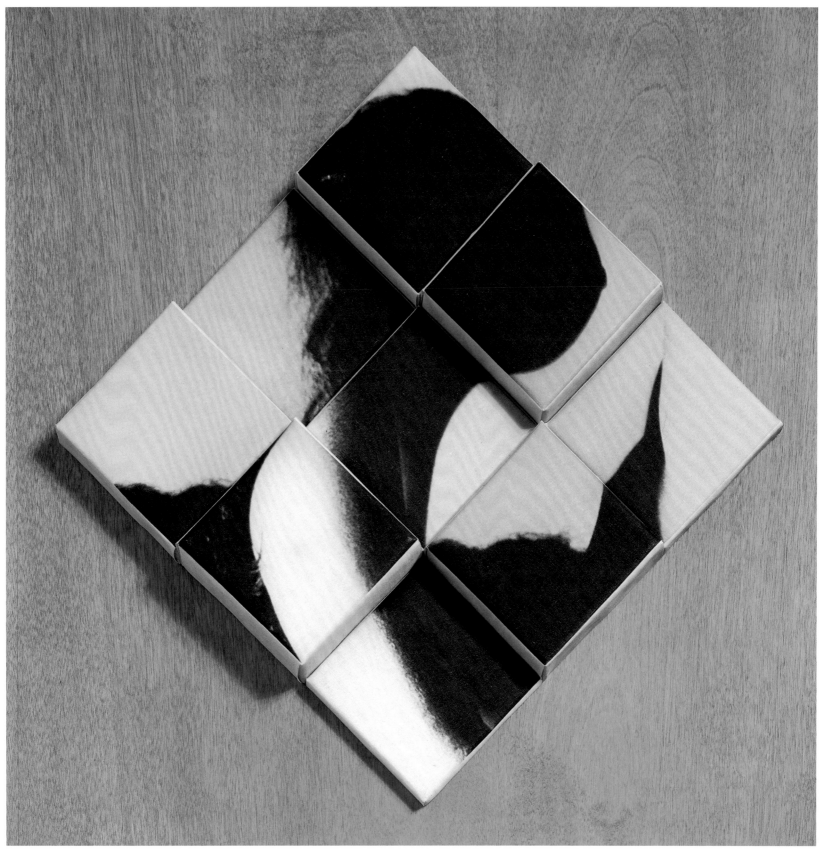

Obviously influenced by Bellmer's dolls and the distorted nudes of André Kertész, Heinecken's *Breast Bomb* (1967) is part of a larger series that divides the female body into a series of fragmented cubes bizarrely rearranged. Historically, the hybridizing of sex and weaponry has had various manifestations. In American culture, the atomic tests on the Bikini Atoll in the South Pacific, for example, have forever linked the mushroom cloud and skimpy swimwear. *Breast Bomb* was made at the height of the U.S. intervention in Southeast Asia and the concurrent countercultural lifestyle revolution. 1967 gave us the "Summer of Love," so this image had a kind of currency of the moment, fusing the themes of sex and war with a psychedelic aesthetic. As evidenced by the collection of "political" buttons in the Heinecken archive, popular youth culture conflated politics, sex, and humor in sometimes liberating and sometimes Neanderthalish ways. Alongside traditional campaign buttons for the pacifist presidential candidate Eugene McCarthy, for instance, are the sayings "Lay Don't Slay," "Cure Virginity," "Pot, Peace, Pussy, Perversion," and "Women Should Be Obscene And Not Heard."

Bruce Conner, a contemporary of Heinecken, worked these themes brilliantly with films and assemblages that found their sources in the actual images and objects of popular culture. His collaged appropriation films such as *A Movie* (1958) and *Cosmic Ray* (1961) recycle violent and pornographic imagery in hilarious juxtaposition with other film genres to comment on the vulgar spectacles of contemporary life. Not to imply that "critique" should be the underlying foundation of any art that deals with popular culture, but in the films and assemblages of Bruce Conner one observes a sensibility that is interested in more than a sensationalist or gratuitous use of such loaded imagery. By contrast, one gets the feeling that even in its reconstituted state, Heinecken's work with pornography was devoid of content much beyond the sexual stimulation that these pictures ostensibly provide. That he seems to like or even revel in sexual imagery is no sin. Heinecken's misstep was that he conflated his sexual fetishes with vague political notions, making the effect of his pictures every bit as misshapen as his female figures.

43
From Heinecken's button collection, n.d.

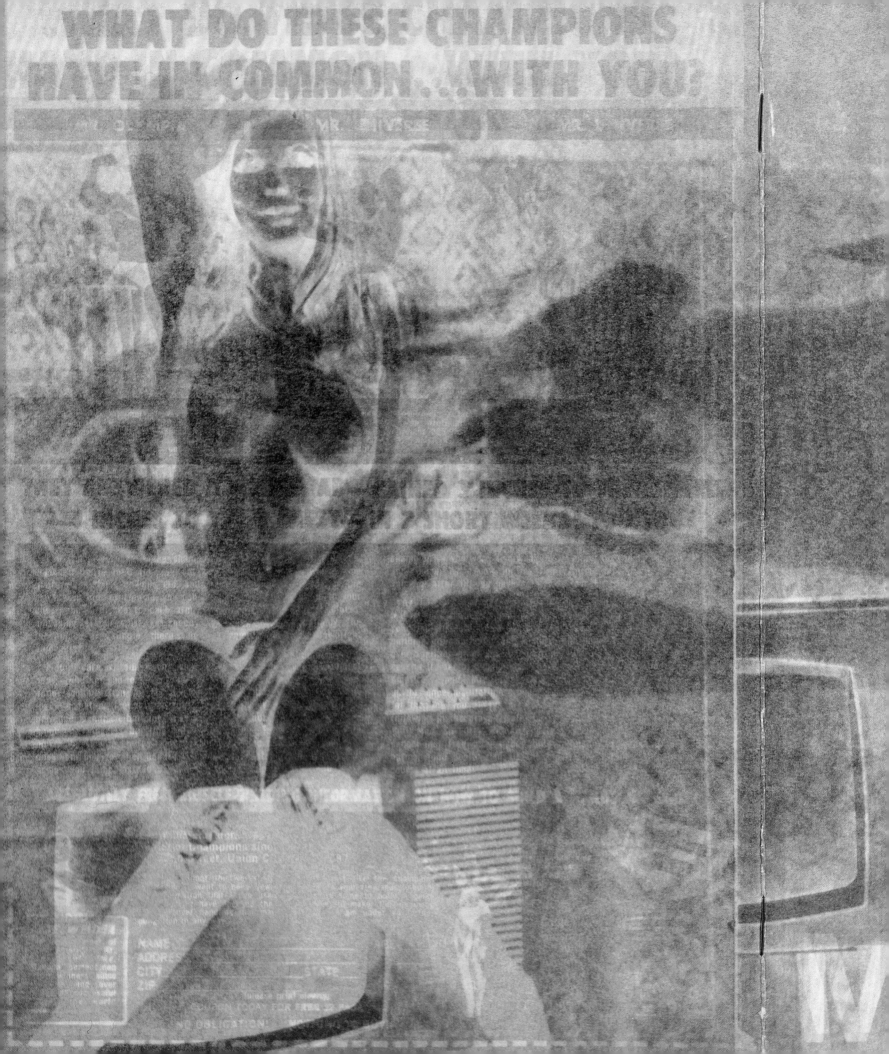

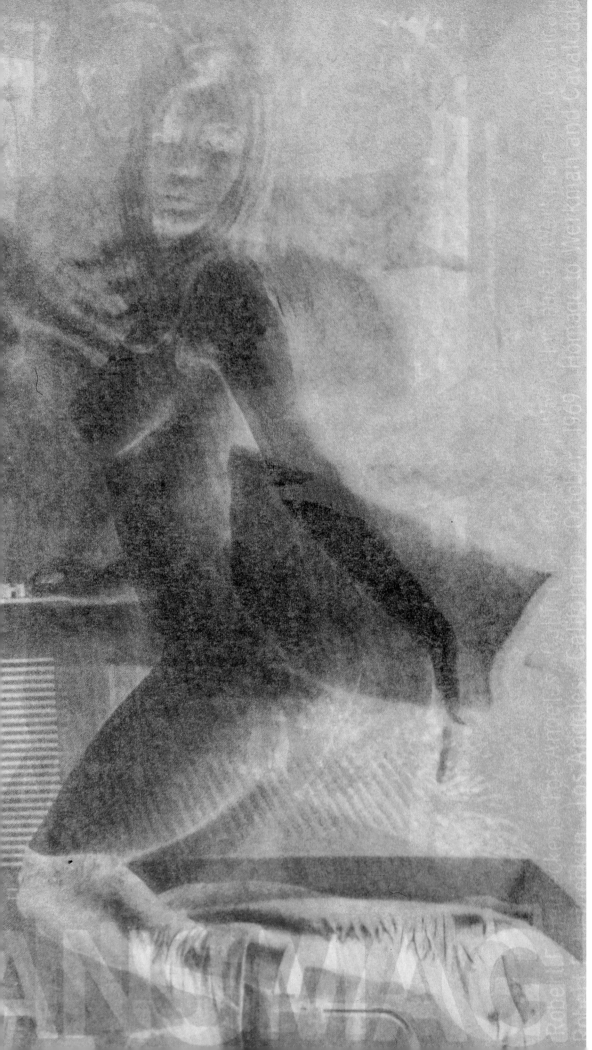

44
Cover from MANSMAG
1969, Artist's book/offset lithography,
22.3 x 16.6 cm
93:020:002/Gift of the artist

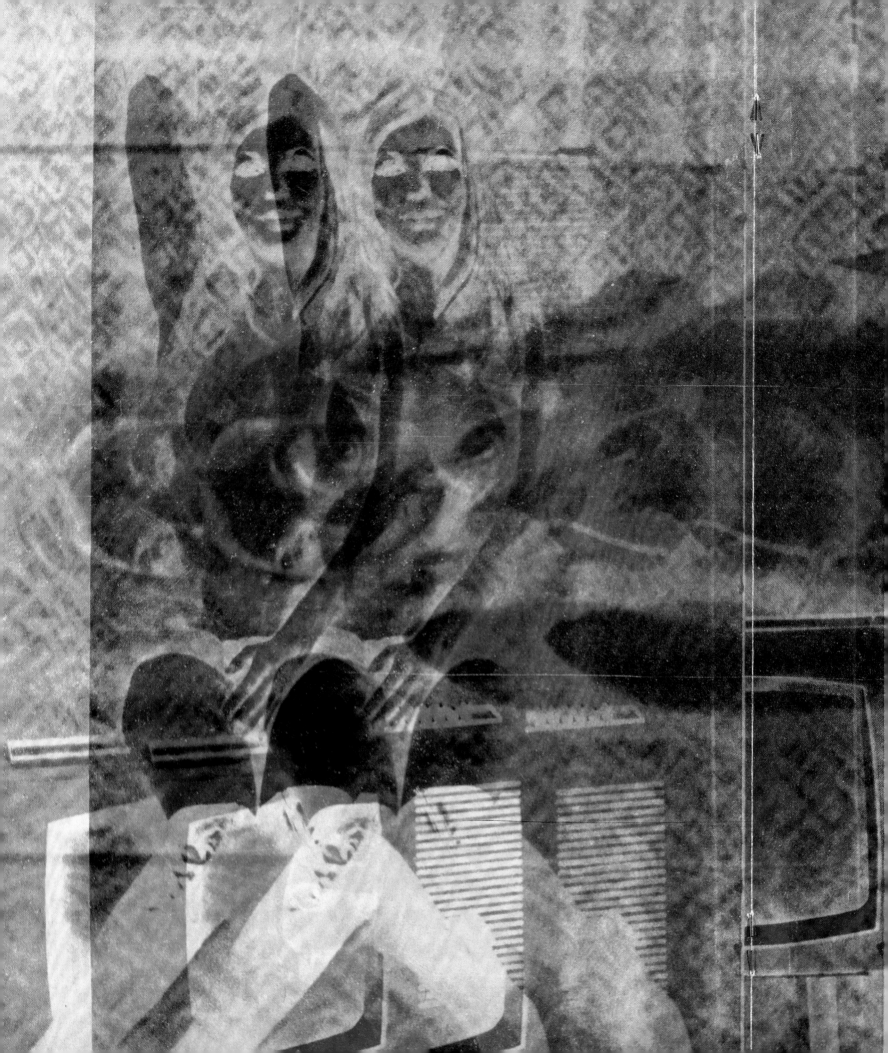

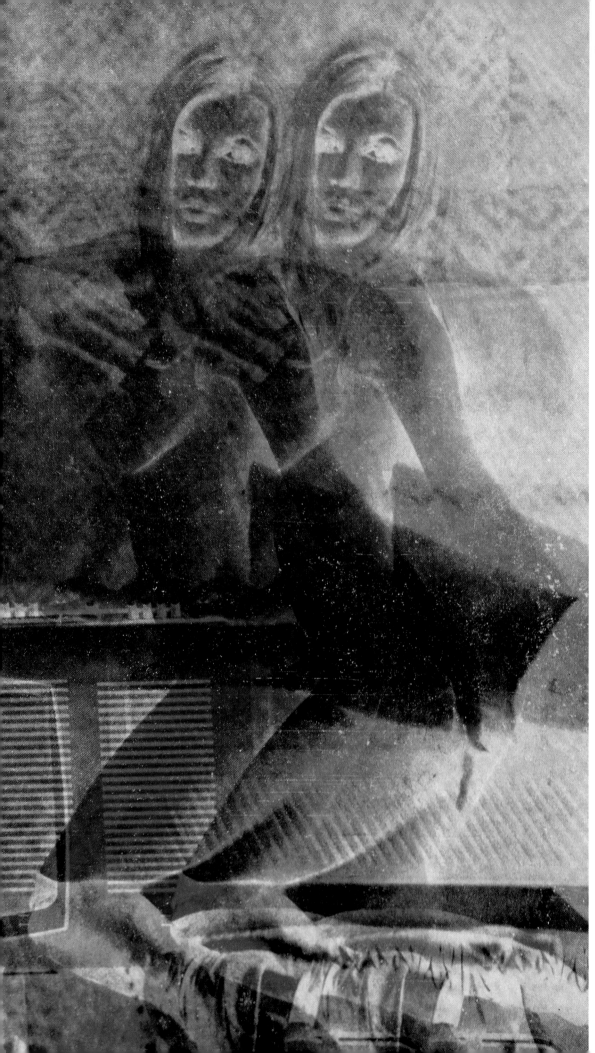

45
Pages from MANSMAG
1969, Artist's book/offset lithography,
22.3 x 16.6 cm
93:020:002/Gift of the artist

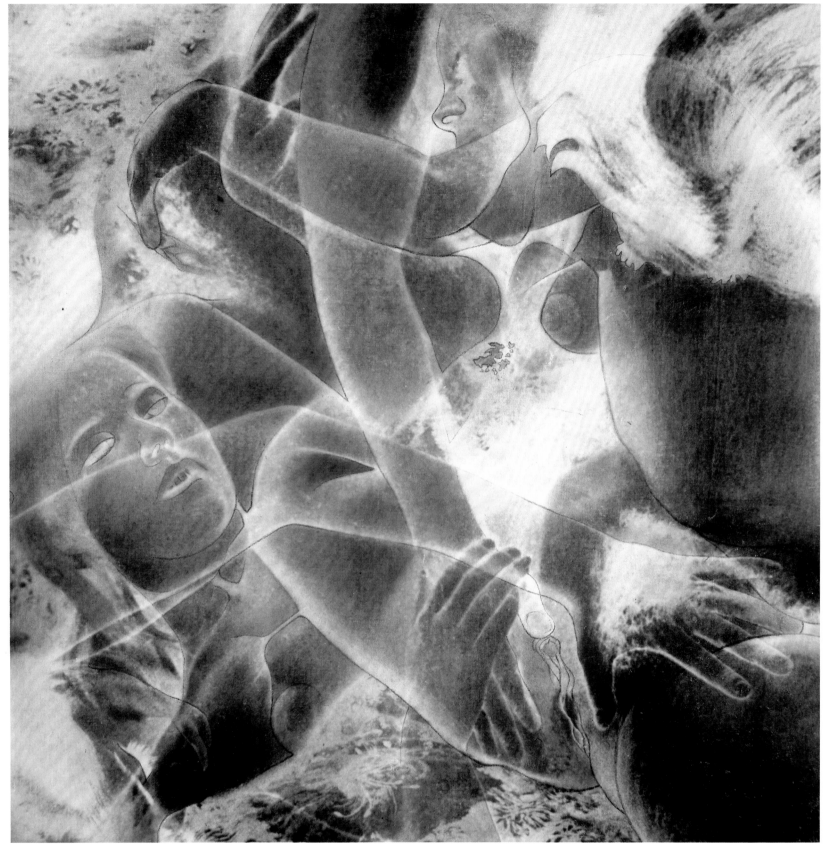

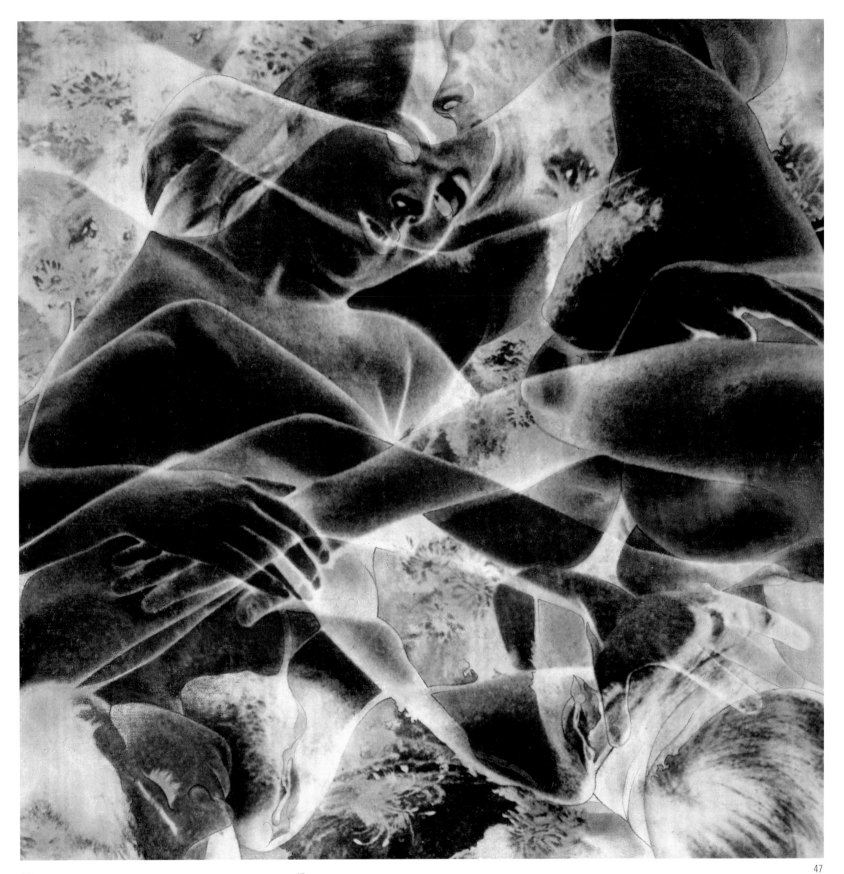

46

**EROGENOUS ZONE SYSTEM EXERCISE #3**

1972, Photo emulsion on canvas, hand-colored
with chalk and pencil, 69.0 x 70.2 cm

81:107:015/Purchase

47

**EROGENOUS ZONE SYSTEM EXERCISE #4**

1972, Photo emulsion on canvas, hand-colored
with chalk and pencil, 48.4 x 48.4 cm

81:107:014/Purchase

48
Study for
**CLICHÉ VARY/AUTOEROTICISM,**
ca. 1974

49
Study for
**CLICHÉ VARY/LESBIANISM,**
ca. 1974

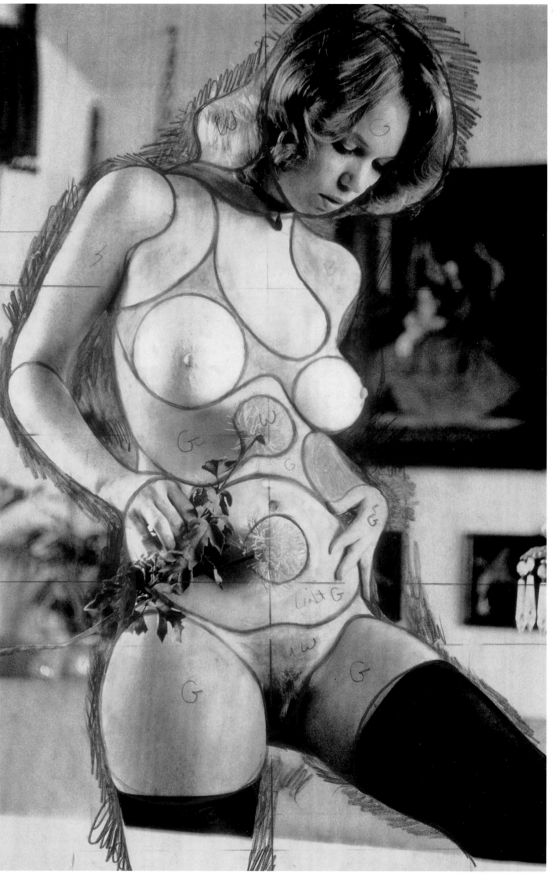

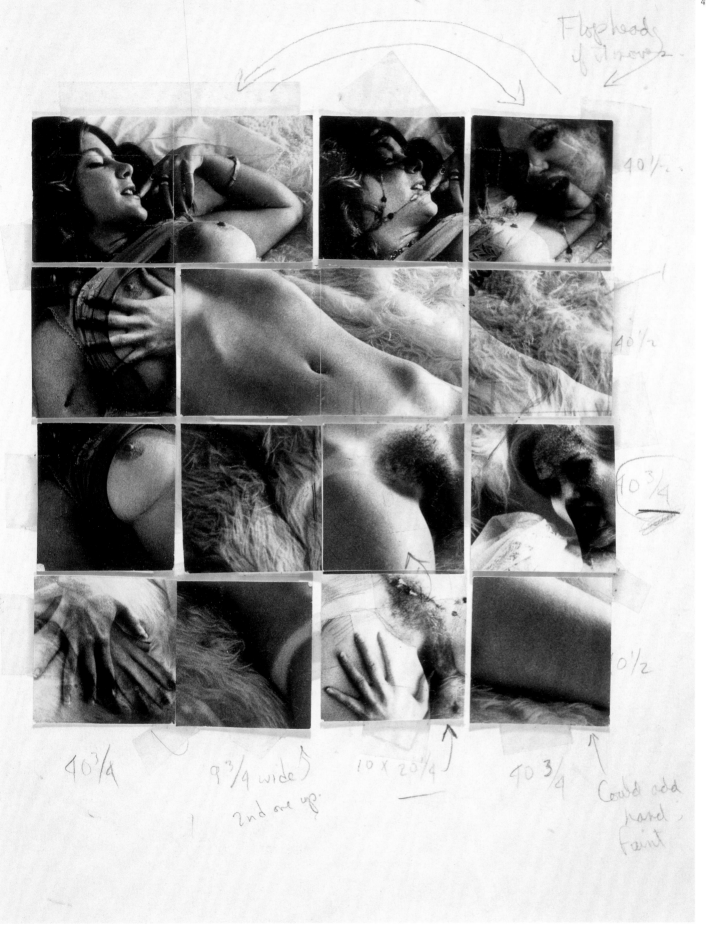

**14 OR 15 BUFFALO LADIES #2 (V)**
July 1969, Offset lithograph, hand-colored
with pencil, chalk and ink, 38.5 x 27.6 cm
81:008:013/Gift of the artist

51

**14 OR 15 BUFFALO LADIES #1**
July 1969, Offset lithograph, 43.4 x 30.8 cm
79:046:003/National Endowment for the Arts
Museum Purchase, 1979

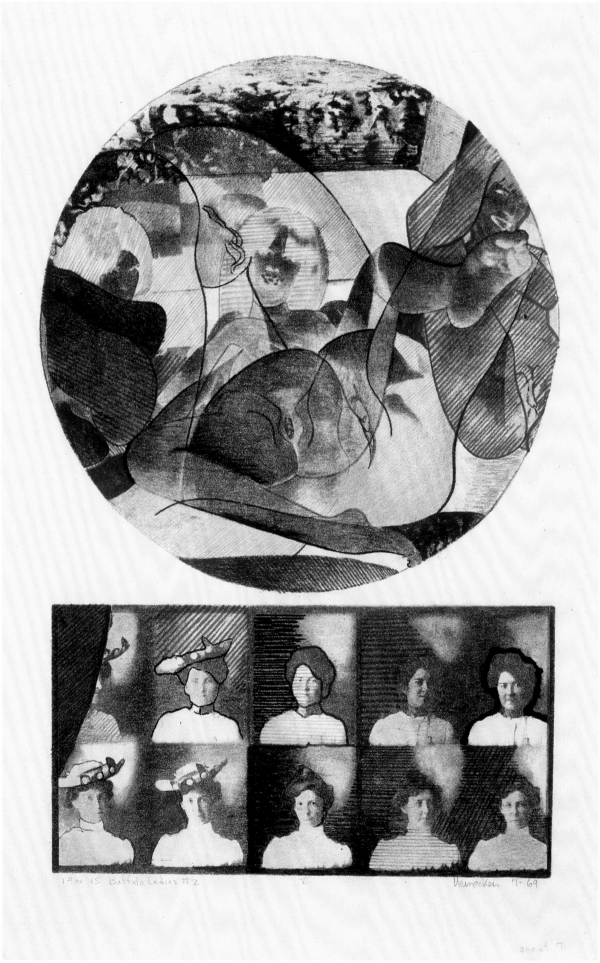

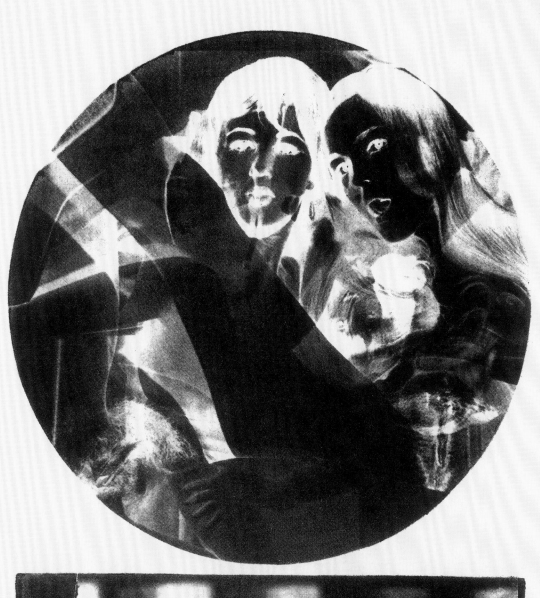

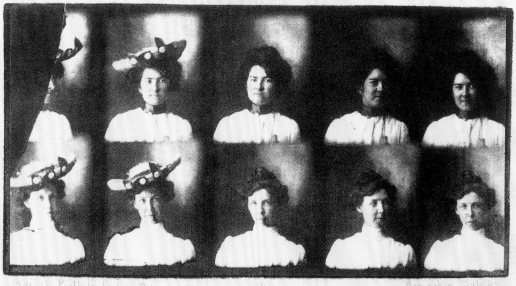

## MAGAZINE PAGE INTERVENTIONS

I am interested in what I term *gestalts*; picture circumstances which bring together disparate images or ideas so as to form new meanings and new configurations…. In this vein, it is the incongruous, the ironic and the satirical which interest me, particularly in socio/political or sexual/erotic contexts. I sometimes visualize myself as a bizarre guerrilla, investing in a kind of humorous warfare in which a series of minimal, direct, invented acts result in maximum extrinsic effect, but without consistent rationale.[14]

As he makes clear in the above statement, Heinecken considered himself a "guerrilla" artist, and many who have written about him have also used this term. The concept implies a sort of low-level warfare in which an underequipped but righteous adversary takes on a dominant enemy, as if Heinecken were a man of the people wielding only his wit and an X-acto blade against evil capitalists. The idea that artists are subversive, oppositional figures derives from the stale myth of an anti-bourgeois avant-garde combined with echoes of the radical chic of the 1960s. Although the notion of an individual artist taking on the advertising industry might seem poetically quixotic, I think it more likely serves to inflate the self-importance of the artist while ignoring the fact that the art world is a pretty ineffective place from which to stage a revolution. One critic recently went so far as to call Heinecken's work "cultural sabotage," as if the very wheels of industry could be halted by an artist altering a Gap ad.

That being said, in addition to the porno-manipulations of the late 1960s through the mid-1970s, Heinecken continued his magazine interventions. His procedures became more direct and physically aggressive and in this sense there is something predatory about his activities, as if he were prowling the gutters of magazines looking for appropriate victims. Among other things, he rearranged the pages of dozens of magazines within one cover, made razor-sharp excisions in glossy ads, printed violent or sexual images onto the pages of current issues, and placed them back on newsstands. With these simple gestures he intervened more immediately into the language of advertising. The photogram images of *Are You*

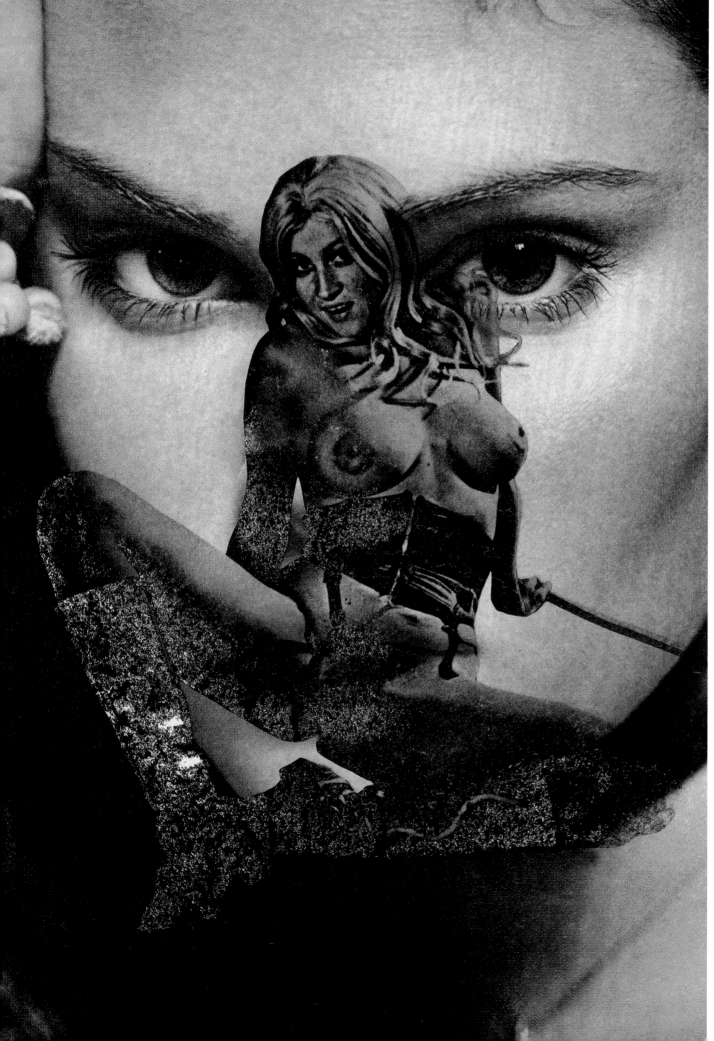

# to Paradise By BEVERLEY

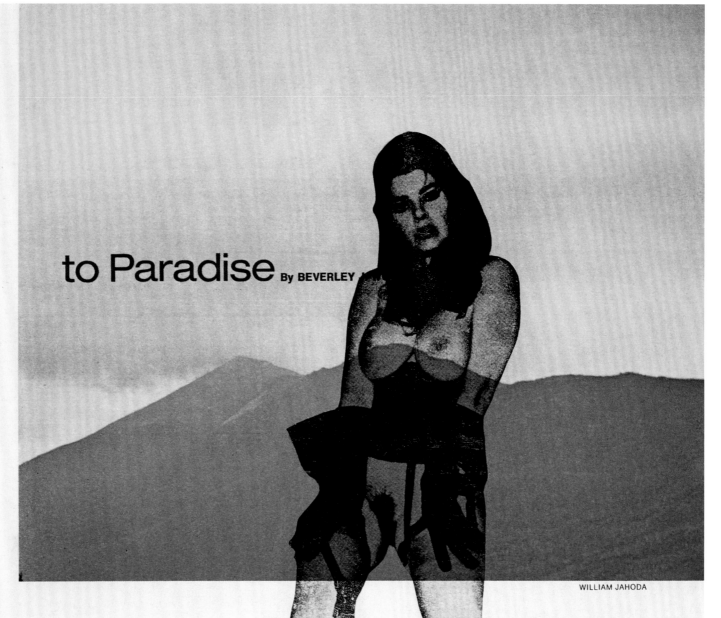

WILLIAM JAHODA

only means of transportation, your two feet. Good-fitting, soft, light, high-topped hiking boots are generally the best and there are now several very good, fairly inexpensive brands available. The kind with the tongue fully or partly attached at the sides is best for helping keep feet dry. Make sure the insole is leather, not cardboard imitation. We learned the importance of this after a sad experience with a child's cheap boots; after a wetting, the inside sole crumpled up and disintegrated. Luckily for his feet, we had with us a pair of foam-rubber insoles that we were able to fit into his boots. It's a scary thing to be suddenly bootless twenty-five miles or so from civilization. So shop carefully when you buy boots—your life could depend upon them! They should be thoroughly waterproofed with silicon-impregnated wax, or several good aerosol-spray water repellents are recommended.

A little trick for lacing your boots comfortably (and they must be laced tightly, to prevent rubbing and blisters)—lace them instep-high, then twist the laces together, or if the laces are long enough, take a turn twice around the ankle, then continue lacing to the top. This keeps the laces from tightening at the top of the boot, leaving your

ankle unsupported and your foot loose in the boot. We like to wear two pairs of socks—long heavy wool or part-wool socks over a thin, close-fitting pair—for comfort and protection. A sprinkle of foot powder in socks and boots keeps feet comfortable and dry, too.

Next on the list are long sturdy pants with plenty of pockets; they shouldn't be brand-new because the stiff material is apt to rub painfully. They should be loose-fitting enough to let you move freely and to wear over your longies if the day or night is icy cold. And, ladies, beware of zippers in the back; the torture caused by a metal pack frame rubbing on a metal zipper is unbelievable. For the upper half, a cotton knit undershirt and a long-sleeved high-collared cotton shirt are usually adequate during the hiking hours, for even though the altitude is high and the air is cool, hiking is hard work and jackets will soon be shed. Add for the ladies, especially, soft gloves to protect your hands from sunburn and dryness; a soft, light, big-brimmed hat; sunglasses; and a soft cotton bandanna to tie around your neck or over your ears as protection from sun and bugs. A versatile little object, this scarf can also be pressed into (continued on page 108)

*Rea* achieve a perverse beauty by creating a dark and grainy palimpsest, a multi-layered translucency inhabited by seductive ghosts. In contrast, the magazine work of this period is much more brutal and polemical. At times Heinecken employed deceptively simple and surprisingly effective methods such as razoring out the eyes and mouths of brightly smiling models, making these formally lovely specimens appear either completely vacant or possessed by the Anti-Christ. They are marvelous anti-icons of materialism.

To purchase and peruse the pages of a magazine is to accept its pictorial and textual natural laws. Reciprocally, there are certain expectations the reader has when opening the pages of *Sports Illustrated* or *Better Homes and Gardens*. If the relationships of an ecosystem are challenged by the introduction of a foreign element into that established world, then suddenly the idea of what is "natural" becomes contested. This is the basic concept of Heinecken's magazine manipulations; by printing an image of a woman in a dominatrix costume across the homogenized repertoire of fashion postures, this previously safe and unquestioned world is interrupted. The perfect dinner party planned by *Vogue* or *Cosmopolitan* is ruined by the uninvited leather-clad guest.

It is relevant here to remember that Heinecken was initially a printmaker whose relationship to an image is different from that of a painter or photographer. Traditionally, the painter attempts to create a single masterpiece and the images made on the way to that singularity are considered sketches and therefore preliminary and minor works. The photographer will make multiples of a final image, but generally each one is exactly the same as the last, tonal consistency being the priority of an edition of prints. Heinecken cares not for such arbitrary rules of engagement. Each intervention is a unique experience, each juxtaposition potentially explosive. In virtually all of these forced marriages, the violence of the artistic gesture is dramatic and unforgiving. One of Heinecken's most infamous interventions involves the image of a smiling Asian soldier clutching two severed heads by the hair, one in each hand. He made a lithographic plate of this terrible photograph and printed it upon literally thousands of magazine pages.

53
Offset lithography on magazine page, 1971

54
Offset lithographic plate, 31.5 x 23.5 cm, 1971

55
Offset lithography on magazine page, 1971

54

# This is the way Love is in 1970.

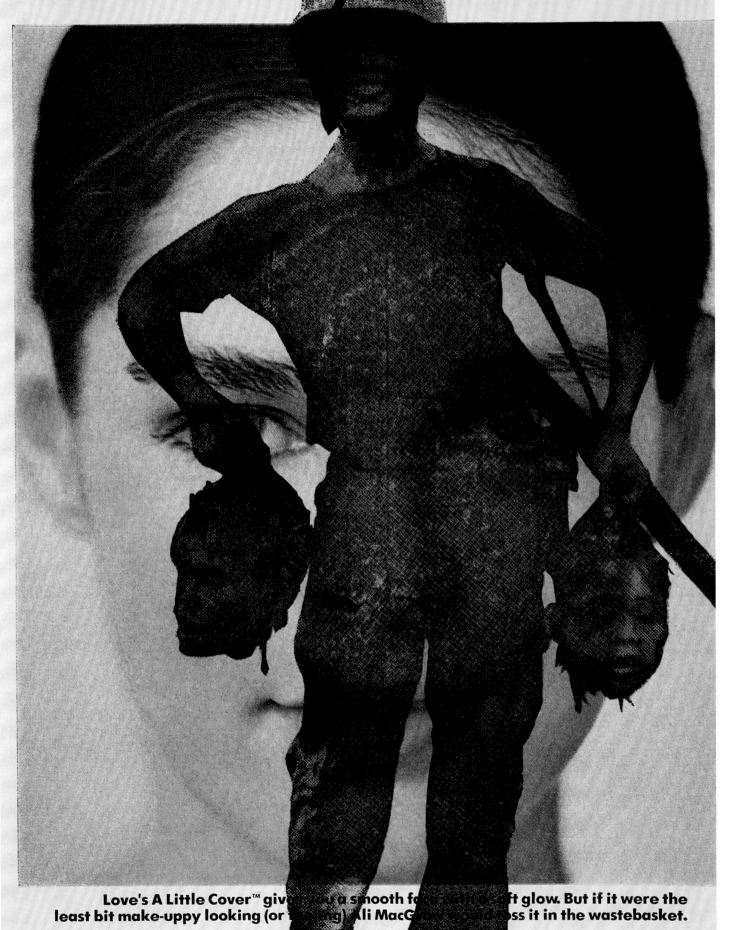

**Love's A Little Cover™** gives you a smooth face with a soft glow. But if it were the least bit make-uppy looking (or feeling) Ali MacGraw would toss it in the wastebasket.

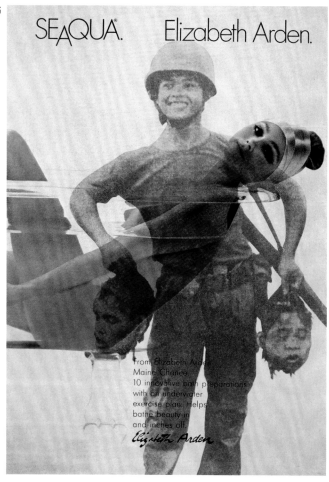

SEAQUA. Elizabeth Arden.

From Elizabeth Arden
Maine Chance.
10 innovative bath preparations
with an underwater
exercise plan. Helps
bathe beauty in
and inches off.

*Elizabeth Arden*

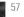

AMERICA
WHERE YOU CAN LOOK LIKE THIS
AND DO ALL THAT ➤

# The glare-killers are man-killers now.

Listen. You know those famous shades? With the optical barrier that kills reflected glare? Cool-Ray Polaroid Sunglasses? Well, you ought to see them today. There are metal frames. There are huge shapes: rounds, hexagons, free forms. You put them on, and they not only make the world look great to you. They make *you* look great to the world. The glare-killers are man-killers now! Get the Cool-Ray Polaroid Sunglasses. Then pick up a man. See what happens. (Suggested retail prices go like this: *Right Sun Shades*, $7.)

The Sexy Shades:
Cool-Ray Polaroid Sunglasses

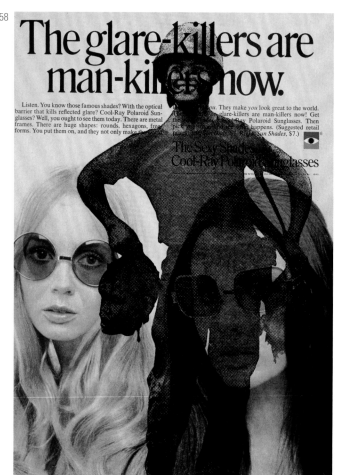

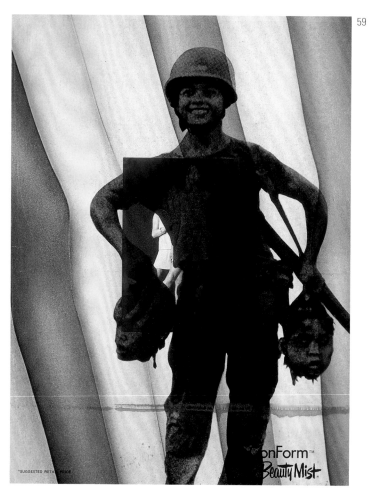

*SUGGESTED RETAIL PRICE

onForm
*Beauty Mist*

Heinecken's most "guerrilla-like" action occurred one morning in 1971, when he made off with several bundles of magazines from a newsstand, only to return them a short time later with the grim soldier and his bloody souvenirs printed across the majority of pages. One can only imagine the horror of the buyer who was greeted with this incessantly repeating image of cruelty, immediately recognizable as belonging to the repertoire of atrocities in a faraway place known as Vietnam. By superimposing this image on any manner of printed material, the highly filtered and codified naturalism of media imagery becomes evident; the masquerade of "normality" is revealed and mocked. It is in this work that Heinecken comes closest to being a "guerrilla" artist, stepping outside the rarefied confines of the gallery and classroom, temporarily clogging a few of the escape hatches of entertainment and acquisitiveness with violent fragments of contemporary events.

56 – 59
Offset lithography on magazine pages, 1971

# Anecdotal Triptych III

ALCOHOL

I often found myself accompanying my father to a bar, usually the V.F.W. (Veterans of Foreign War), referred to as "the club" by my parents. For some reason, my town had blue laws forbidding bars as well as liquor sales in restaurants, despite the fact that the neighboring towns of Somerville, Charlestown, Malden, and Cambridge (working-class suburbs of Boston) seemed to have saloons and cocktail lounges on virtually every major street corner. Private clubs, such as the V.F.W., the Elks, and the Italian-American Club, were where a guy could get a drink and see the boys most hours of the day and night. Being the oldest son, a privileged acolyte, and sometime bar mascot, I was stationed by my father at a pinball machine with a fistful of quarters and I would while away the afternoon mesmerized by the flippers, lights, and bells of pinball or the sandy whoosh of shuffleboard bowling. ¶ My father would slip onto a barstool in the next room and order his first highball. Beneath the television set mounted high in the corner were bottles of Canadian Club and Seagram's VO. Cases of Schlitz, Narragansett, and Black Label beer occupied the sawdust-strewn floor. I remember these afternoons as early training in what seemed to me, even then, the incomprehensible behavior of men. I was literally and figuratively in the grade school of a particular model of maleness, learning what men did together when not restricted by the etiquette of the family home or the company of women. I vividly recall the image in which a half-dozen or so of my dad's drinking buddies were smoking, laughing, and telling dirty jokes when Sinatra's anthem "I Did It My Way" began playing on the jukebox. ¶ I stood at the periphery as these men put their arms around each other and swayed back and forth in the smoky blue light. Cigarettes and tinkling cocktail glasses ornamented their hands as the group mutated into a multi-headed chorus line for Frank's bravado. Their mouths seemed blurry, defined only by the stubble that encircled their lips as they sang: "and regrets, I've had a few, but then again, too few to mention." A cacophonous and slurring crescendo, like a premature ejaculation, sprayed across the room, after which they fell back into their stools. A brief but very distinct silence descended over their inebriated and working-class conceit. These men, just a moment ago so familiar, now appeared alien, as the mood hung suspended, brooding, and sore. The murmur of the Celtics game revived their attentions, and spelunking out of their dark corners, they returned to smoking, sipping, and sports. —MAD

He: What's your name?
She: Brandy.
He: As in the liquor?
She: Yes.
He: Is it an assumed proffessional name?
She: No, but I suppose it does imply a particular look, or equivalent image.
He: Like a center fold name?
She: As a matter of fact, I did that once.
He: I never believed that those women really existed.
She: Some don't.
He: What's your family name?
She: Alexander.
He: Then your parents...?
She: Drank them once.

61

# HE SAID, SHE SAID

Each understands only their set of rules, concocted or deliberately brewed out of their unique experiences in these matters. Both have won and lost, and are aware that one person or the other is the more sure-footed. Each knows well that the most fulfilling games result in a tie, and there are no overtime periods. Alcohol is frequently an involuntary referee. I could be the exact model for these suppositions.[15]

The body of work known as *He:/She:* marks a change in Heinecken's process, at least on the material level. This change was precipitated by three dramatic events in Heinecken's life: a divorce, a studio fire that destroyed two years' worth of work, and a traveling solo exhibition which received a great deal of attention. Heinecken was at the height of his notoriety in the mid-to-late 1970s. A quick review of the covers of *Afterimage*, the influential journal published by the Visual Studies Workshop, would make one assume that Heinecken had become canonical, a name unalterably etched in the history of photography. But Heinecken's reputation would suffer in the contest between the feminist critique of representation and his problematic works of this period.

The conversations of *He:/She:* operate in a literary space somewhere between Raymond Carver and *Penthouse Forum* with shades of Charles Bukowski. These photo-text pieces from 1975 to 1978 are constructed from Polaroid SX-70 prints combined with highly charged conversations inscribed in pen or pencil. They are related to and informed by conceptual art in that these works lack the traditional notions of beauty and preciousness of the art object and employ the most utilitarian means with which to express the "idea" of art. Additionally, the intimate relationship between performance art and photography is seen in the self-conscious theatricality of the images. Heinecken challenges himself to make art out of unprecious, throwaway materials like instant prints and snippets of dialogue. Implicitly or explicitly, he was also responding to the burgeoning feminist movement of the 1970s, in which male assumptions about femininity (and by extension, masculinity) were being assailed. In this sense, the exchanges of *He:/She:* are like hypothetical theatrical sketches of sexual antagonism between modern urban couples and/or verbal foreplay in some arty porn film.

She: What's the matter kid? Got the blues?
He: Yeah.
She: Your woman's giving you shit, right?
He: Right.
She: Listen honey, when I'm pissed off jealous,
I do the most violent physical thing I can think of.
I kick em in the fuckin balls - hard.
He: I...
She: Jesus kid. It's simple - You either have someone
to love, or you don't.

#1 of 2 Heinecken 77-79 ©

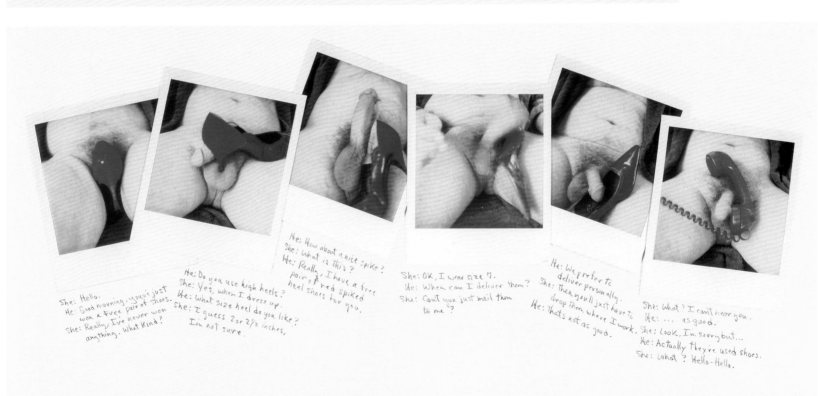

She: Hello.
He: Good morning, you've just won a free pair of shoes.
She: Really, I've never won anything. What kind?

He: Do you use high heels?
She: Yes, when I dress up.
He: What size heel do you like?
She: I guess 2 or 2½ inches, I'm not sure.

He: How about a nice spike?
She: What is this?
He: Really, I have a free pair of red spiked heel shoes for you.

She: OK, I wear size 7.
He: When can I deliver them?
She: Can't you just mail them to me?

He: We prefer to deliver personally.
She: Then you'll just have to drop them where I work.
He: That's not as good.

She: What? I can't hear you.
He: ... as good.
She: Look, I'm sorry but...
He: Actually they're used shoes.
She: What? Hello-Hello.

Ostensibly the Auto Cross, Used Shoe, Red Word, Valentine Joy, Phone Fetish, Polaroid Puzzle. #3 of 4      Heinecken-February 1977

He: I like pool for its' geometry.
She: I like its' cool wetness.
He: What?
She: Its' cool fluid wetness.
He: Never mind.
She: I failed geometry.

He: How many times have you made love?
She: 312.
He: Exactly 312?
She: Yes, once every sunday morning for 6 years.
He: You certainly didn't fail arithmetic.

Heinecken © 1975-78 #1082

64

**HE: I LIKE POOL FOR ITS GEOMETRY**
1975-78, from the series *He:/She:*
Polaroid SX-70 Land prints and text on board,
38.0 x 50.8 cm, 81:105:008/Gift of the artist

65

**HE: THAT'S A VERY NICE PLACE FOR A MOLE**
1977, from the series *He:/She:*
Polaroid SX-70 Land prints and text on board,
50.8 x 38.0 cm, 81:105:012/Gift of the artist

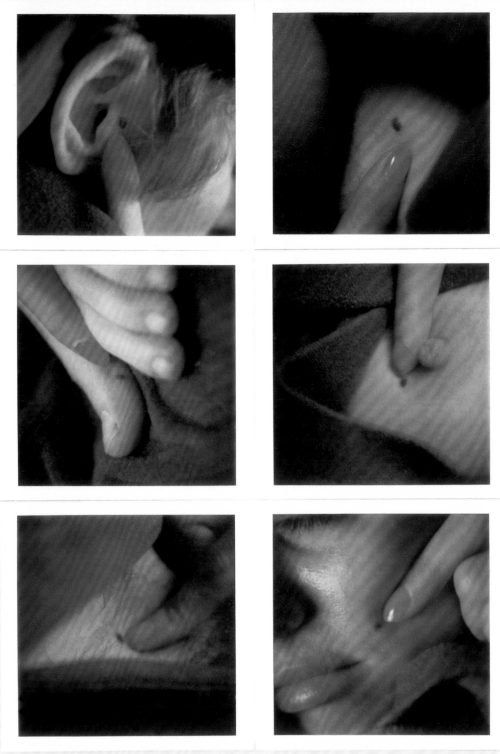

He: That's a very nice place for a mole.
She: All 6 of my moles live in the right places.
He: It sounds kind of like a family.
She: A mole is that special erotic locus of pigmentation
     which is residual from that time when we were
     animals - and lived underground.
He: When does a mole become a beauty mark?
She: As you put your tongue on it.
                                   Heinecken May '77  1 of 10 ©

Many of the conversations of *He:/She:* were inspired by actual encounters in Heinecken's life, but even if we assume that the words are entirely fictional, much is revealed about his self-image in his various roles as artist, teacher, and lover. These works give the impression of being more directly autobiographical than anything else in his art, an impression reinforced by Heinecken's physical presence in many of the pictures. The verbal play is often sardonic and adversarial. Heinecken as the "He" character expresses himself in elusive, patronizing, and sometimes self-mocking tones. The "She" is often clever and accusatory, but usually portrayed as somewhat naïve compared to the older, jaded, and ultimately detached male protagonist.

She: Are you happy with me?
He:  Usually.
She: What makes you happy?
He:  Not being asked about it.

That exchange is illustrated with a Polaroid triptych showing an unshod foot stretching across bedsheets; bottles of alcohol, an ice bucket, and cigarettes chaotically arranged on what might be a hotel room dresser; and Heinecken himself, framed by tacky drapery, standing bare-legged in a T-shirt. The blue light of early morning emanates outside the window, suggesting an all-night affair.

In another triptych, each frame shows a woman whose head is truncated by the frame. Two images show the woman in a man's shirt, unbuttoned and exposing a breast. A Polaroid image protrudes from each pocket, a vagina from one and a penis from the other. The central image shows a woman's naked torso with a giant crab about to lunch on her genitalia.

He:  I can actually smell those women who want me.
She: What did I smell like?
He:  It's not an individual smell.
She: Bastard.

Occasionally, the balance of power in the quip department is tipped in favor of "She." In a three-faced triptych of Heinecken, he stares back into the camera as if the lens were the eyes of his interrogator. The dialogue reads:

He:  Did you enjoy the exhibition?
She: It's funny. Every time you walk into a room, something magic happens.
He:  I'm never sure if it's…
She: They all put you on a pedestal.
He:  It's a pedestal with a trap door in it, like a gallows.
She: Except that you hold the handle.

Heinecken refused to separate his sexual desire from his desire to be politically provocative; this naturally led to some pretty murky territory. For Heinecken, the exchanges of *He:/She:* may have represented the archetypal battle of the sexes. This sexually charged but ultimately patronizing verbal jousting was a contemporary form of what he evidently believed to be the age-old antagonism between men and women. But the intended humor of *He:/She:* seems to have been lost in the intervening years, although clearly some people never thought it was funny. Like Johnny Carson doing his standup routine in the offices of *Ms.* magazine or an off-color joke that goes flat in mixed company, there is something embarrassing in the anachronistic quality of this work. Personally, I like the banality of *He:/She:* and the unpreciousness of its presentation. I am not interested in scolding Heinecken for inappropriate representations. It's simply that these male/female exchanges, far from being revealing, instead betray a limited and highly circumscribed vision of the machinations of heterosexual power dynamics.

## RECTO/VERSO AND GHOSTS OF REAGAN

In the 1980s Heinecken backed away from the adversarial tones of *He:/She:*, although by this point he had already alienated many in the photographic community. His name and references to his work became less frequent in art journals as the decade wore on. Being as indefatigable as he is, Heinecken continued (and continues to this day) his prolific rate of production, turning his attention to television imagery and more elegant presentations of his media meditations. Heinecken created many works in the 1980s that used television imagery as their source, including an exhaustive faux-semiotic study of a network's search for an appropriate anchorwoman, *CBS Docudrama in Words and Pictures* (1985-1986). Along with the stacked images of newscasters such as Jane Pauley, Joan London, Diane Sawyer, and Connie Chung, Heinecken included a satirical analysis of facial structures that put new clothes on the nineteenth-century pseudo-science of physiognomy. Like watching television in a classroom, there is something disconcerting about seeing these distorted, well-known faces outside the normalizing context of the living room. Heinecken pictured these women as ephemeral icons of the late twentieth century, vague but insidiously familiar.

Among the most haunting of his television-derived imagery are the photograms he made of Ronald Reagan's inaugural speech in 1981. Early in his political career, Ronald Reagan was taken less than seriously; how could a second-tier Hollywood actor have the authority and depth necessary to lead? Reagan later quipped that he did not see how a man could be president and not be an actor. Reagan became a master manipulator of the electronic image, a god of the media age—remote, profoundly indifferent, yet appearing in front of us with a smiling, self-effacing benevolence. In a gesture of calculated simplicity, Heinecken pressed Cibachrome photographic paper against the television screen during the broadcast of Reagan's inauguration, leaving a ghostly impression of the new president upon the paper like Veronica's Veil. Heinecken allowed the photographic paper to absorb the electronic image of a leader who was both omnipresent and vacant, a man who was both anachronistic and completely of his time. Of the billions of images that have passed through our eyes and impressed themselves upon our conscious and unconscious minds, perhaps it is the image of Reagan hovering over millennial America that most aptly embodies the symbolic absence/presence of the varied forms of power over our lives.

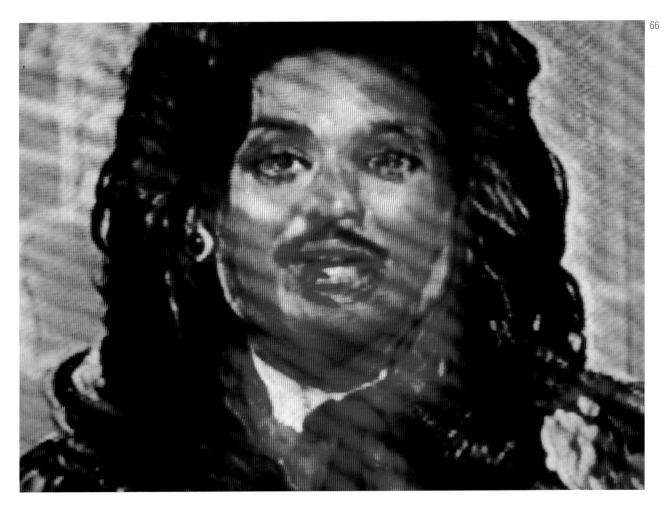

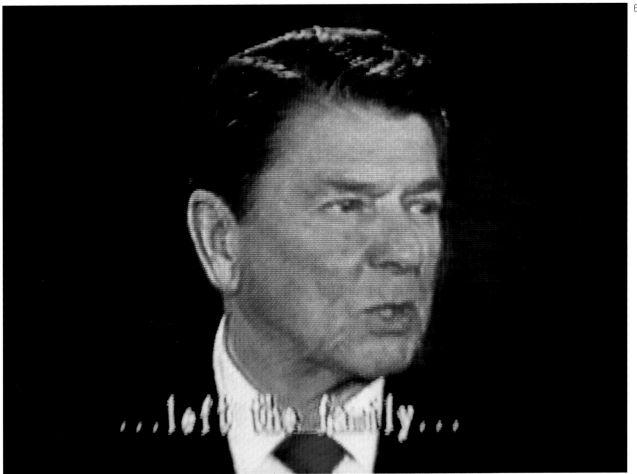

...left the family...

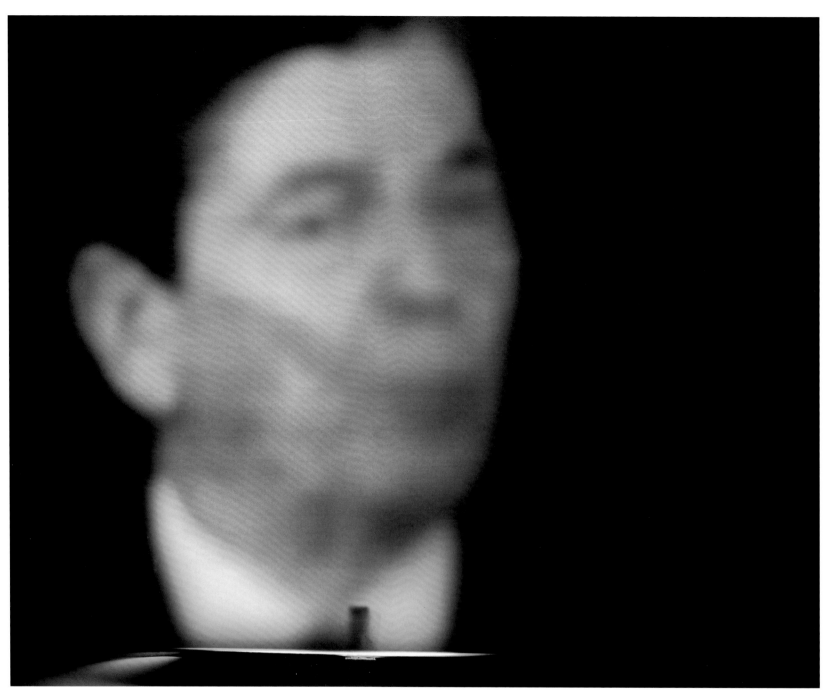

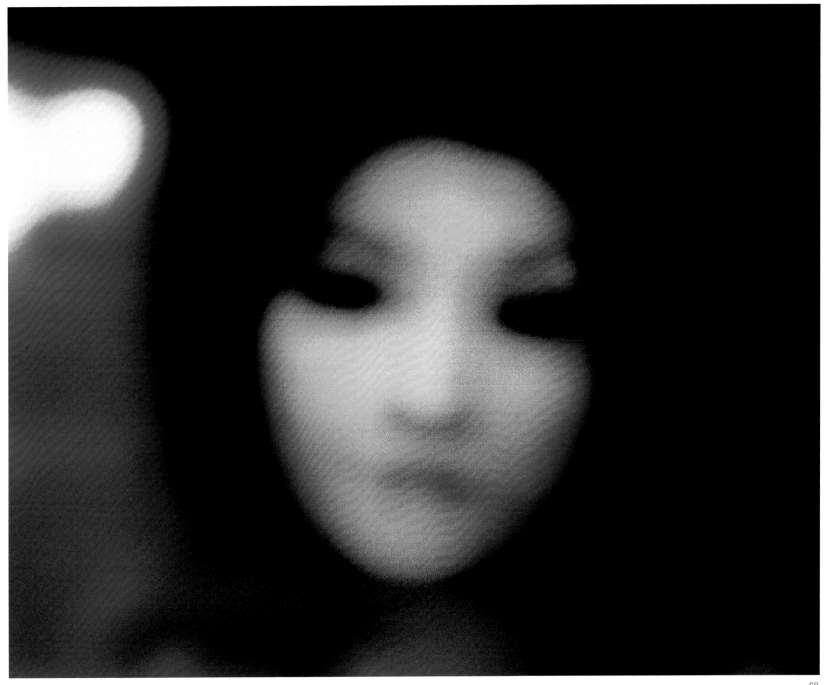

69

68

**INAUGURAL EXCERPT VIDEOGRAM #66/RONALD REAGAN...BE MISJUDGED AS...**
1981, Silver dye bleach print, 27.7 x 35.5 cm
93:003:023/Gift of the artist

69

**UNTITLED NEWSWOMEN (CONNIE CHUNG)**
1985, Fujix Jetgraph 3000 print, 58.7 x 72.5 cm
93:003:029/Gift of the artist

*Recto/Verso* is a portfolio of twelve color Cibachrome photograms from the late 1980s that recall *Are you Rea* but lack the pop-satanic riot of that earlier work. Again Heinecken printed through both sides of magazine pages, but this time onto direct positive color material, obtaining images that are less gritty than their black-and-white counterparts from the 1960s. Instead, they seduce with bejeweled, glossy, and hard surfaces. The image/products featured in *Recto/Verso* are hyper-real yet inaccessible, offering an impenetrable surface, like the skin of a forbidden fruit that we may be tempted to eat but forever resists our efforts to consume. The fetishized textures of fur, crystal, feathers, and pearls dominate these double-image transformations and are as appropriate to the glitzy, self-indulgent 1980s as the dark psychedelia of *Are You Rea* fit the ragged edges of the 1960s.

Heinecken is a far more complex artist than his critics or even many of his defenders admit. From his military background to his free-wheeling hedonism, there is something very American about Heinecken's art and persona. He remains a somewhat inscrutable character. Long before the onslaught of feminist dismissals, Heinecken was routinely criticized by the anxious, proper, or puritanical. In 1973, John Szarkowski proclaimed Heinecken one of the more important young photographic artists of the day. He qualified his praise by insisting on "the joyless sexuality that is central to most of his pictures,"[16] as if to imply that if Heinecken enjoyed the sexual images, then the formal and conceptual innovations of his work would somehow be negated. With his unapologetic and acritical indulgence in what pleases him, he has at times cavalierly provoked trouble for himself. Heinecken has always done it his way regardless of the angry accusations against his "pussy porn."

There are few artist/educators of his stature who have so thoroughly balanced the public and private responsibilities of those roles, yet he still endures critical ridicule. In 1992, Heinecken was chosen "Honored Educator" by the Society for Photographic Education at its national conference held that year in Washington, D.C. In a scathing *Afterimage* review of the entire conference, the writer singled out this gesture toward Heinecken's academic career as a symbol of all that was wrong with the conference in particular and the organization in general. Referring to Heinecken as a "misogynist photographer," the writer reported on the "disappointment and disgust" expressed by the Women's Caucus of SPE at Heinecken's

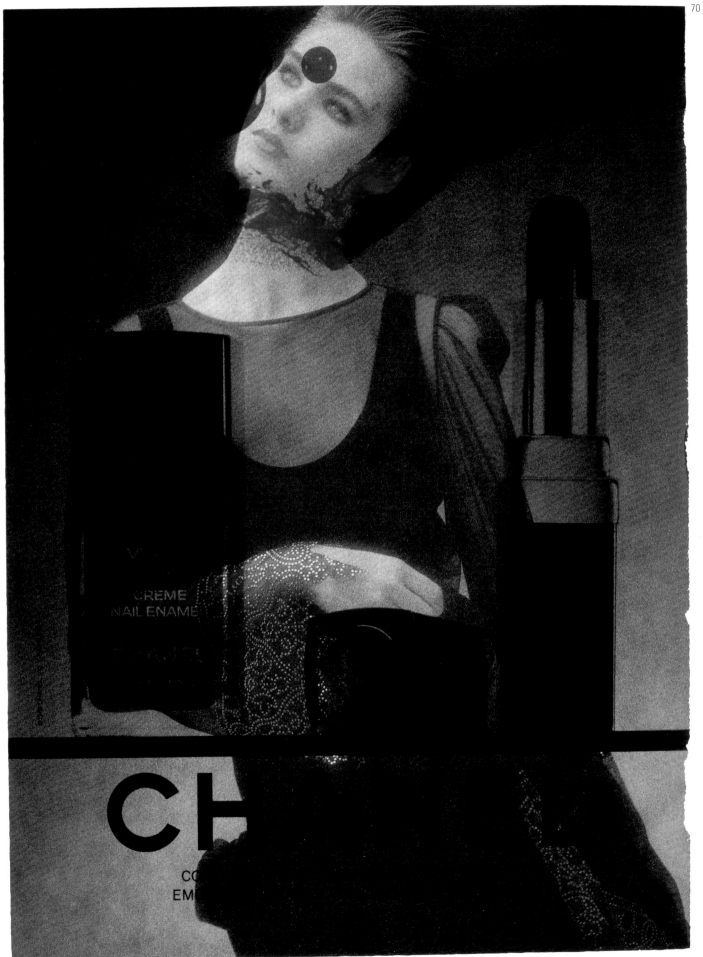

CREME
NAIL ENAMEL

CH

CO
EM

71

RECTO/VERSO #3
1989, from the portfolio *Recto/Verso*
Silver dye bleach print, 27.7 x 20.0 cm
91:014:003/Purchase

72

RECTO/VERSO #10
1989, from the portfolio *Recto/Verso*
Silver dye bleach print, 27.6 x 19.3 cm
91:014:010/Purchase

73

RECTO/VERSO #7
1989, from the portfolio *Recto/Verso*
Silver dye bleach print, 27.5 x 22.0 cm
91:014:007/Purchase

74

RECTO/VERSO #8
1989, from the portfolio *Recto/Verso*
Silver dye bleach print, 26.4 x 20.6 cm
91:014:008/Purchase

selection.[17] I later asked him how he felt about this personal attack. He replied that he did not know whether to be more insulted at being called a "misogynist" or a "photographer."

There is something fundamentally performative about Heinecken's persona. He excelled in playing various "masculine" roles: the military man, the family man, the artist bohemian, the hippie hedonist, the paternal professor, the bastard boyfriend, and the barroom philosopher. His artwork was equally staged, taking on provocative roles in opposition to the generally accepted guidelines of proper photographic art. Where are the sensual peppers and sand dunes? Where are the mountains and majesty? Where are the noble poor and proud indigent? Where are the metaphors about beauty and nature? These are the questions that may have been asked in the early 1960s when Heinecken first began exhibiting his photographic constructions. Where is the ironic distance? What about the "burden of representation"? Where are the theories of Foucault and Lacan? Where is the self-lacerating guilt? These are questions one might have posed a decade or two later. Heinecken, aware of these demands, could not or would not respond, as he was motivated by obsessions that the polite and politically pedigreed would not tolerate.

In the marketplace of gratifications, of both the immediate and forever unfulfilled types, the photographic image is a natural currency. Our culture is built not only on a foundation of higher ideals, but also on the cumulative landfill of cheap reproductions. The insidious strength of our culture seems to lie in the fact that the image-screen which tantalizes our desires grows in strength and mysterious complexity as it prods our envy and stirs us to covet what we do not have. Heinecken is drawn to this power, he recognizes its gravitational pull, and with a mixture of satire, cool formal analysis, and pure surrender to its pleasures, he gathers, rearranges and re-presents these sirens of acquisitiveness. Heinecken does not attempt to stand outside of culture in service of a sterile critique; instead, he gets dirty digging around in the piles of strangely compelling trash. In not apologizing for his appetites, he admits his attraction and complicity in the endless consumption and recycling of desirous images.

ASPARAGUS:
A TASTE
OF
SPRING

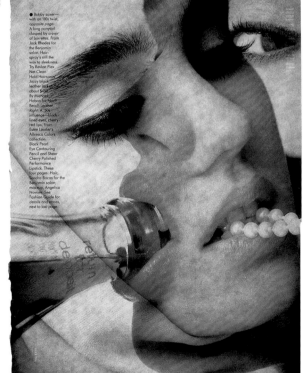

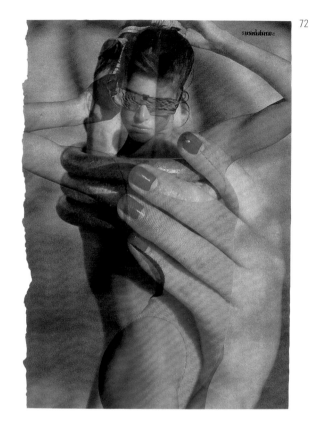

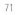

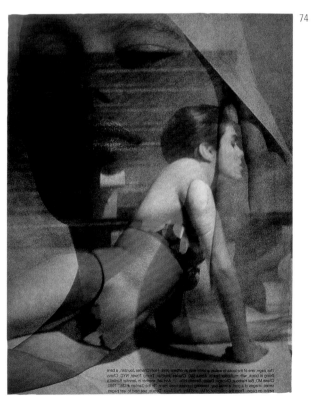

75 – 76
From 8-print polyptych
**PP/WHISKEY-FIGURES**
1991, Silver dye bleach prints,
each approx. 27.2 x 20.5 cm
93:016:006/On extended loan
from the artist

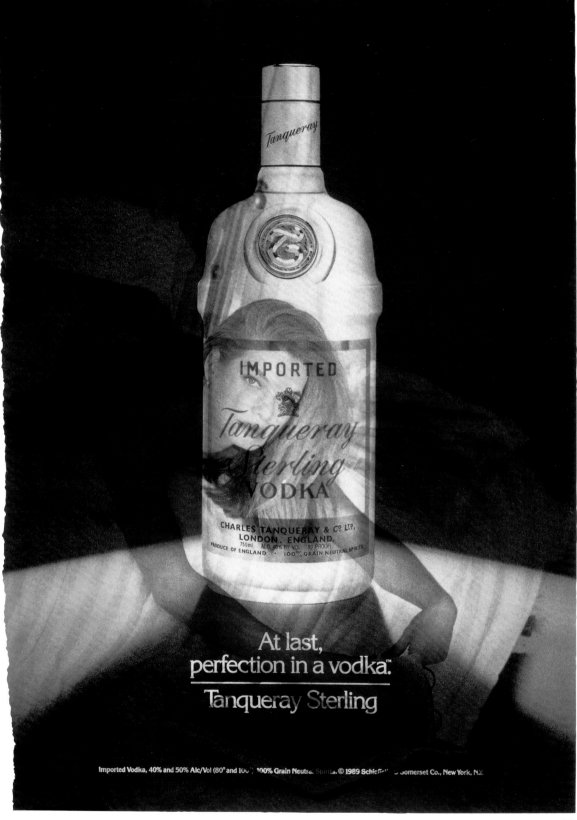

75

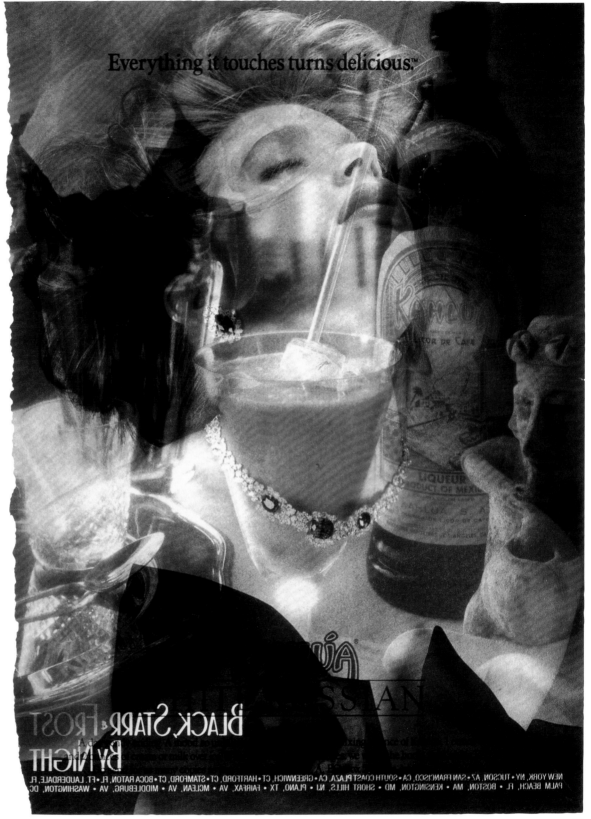

76

## ACKNOWLEDGMENTS

I am grateful to the staff (present and former) of the Center for Creative Photography for their enormous support and for the opportunity to take on this project: Terence Pitts, Leslie Calmes, Dianne Nilsen, Denise Gosé, Marcia Tiede, Janae Huber, Betsi Meissner, Tim Troy, Nancy Lutz, Pat Evans, and Trudy Wilner Stack. I would especially like to thank Roxane Ramos and Amy Rule, with whom it was truly a pleasure to work; without their persistence, this publication would never have been realized.

## NOTES

1 Susan Sontag, *On Photography* (New York: Farrar, Straus and Giroux, 1977), 21.

2 Abigail Solomon-Godeau, "Photography After Art Photography," in *Art After Modernism: Rethinking Representation* (New York and Boston: The New Museum of Contemporary Art and David R. Godine, 1984), 80.

3 Martha Rosler, "Lookers, Buyers, Dealers and Makers: Thoughts on Audience," in *Art After Modernism*, 331.

4 Charles Hagen, "Robert Heinecken: An Interview," *Afterimage* 3, no.10 (April 1976): 9.

5 Charles Desmarais, *Proof: Los Angeles Art and the Photograph, 1960-1980* (Laguna Beach, California: Laguna Art Museum, 1992), 26.

6 Eleanor Antin, quoted in Charles Desmarais, *Proof*, 15.

7 Thomas Crow, *The Rise of the Sixties: American and European Art in the Era of Dissent, 1955-69* (New York: Harry N. Abrams, 1996), 25.

8 Charles Hagen, "Robert Heinecken: An Interview," 10.

9 André Breton, quoted in Robert Heinecken, *Are You Rea, 1964-1968* [portfolio] (Los Angeles, 1968).

10 Robert Heinecken, *Are You Rea, 1964-1968*.

11 Ibid.

12 Charles Hagen, "Robert Heinecken: An Interview," 11.

13 Ibid.

14 Robert Heinecken, "I Am Involved in Learning to Perceive and Use Light," *Untitled* 7/8 (1974): 44.

15 Robert Heinecken, *He:/She*: [artist's book] (Chicago, 1980).

16 John Szarkowski, *Mirrors and Windows, American Photography Since 1960* (New York: The Museum of Modern Art, 1978), 23.

17 Nadine L. McGann, "Dumb Luck at SPE," *Afterimage* 19, no. 10 (May 1992): 3.

# FREE FALL:
# IMPROVISATION ON AN ARCHIVE

AMY RULE

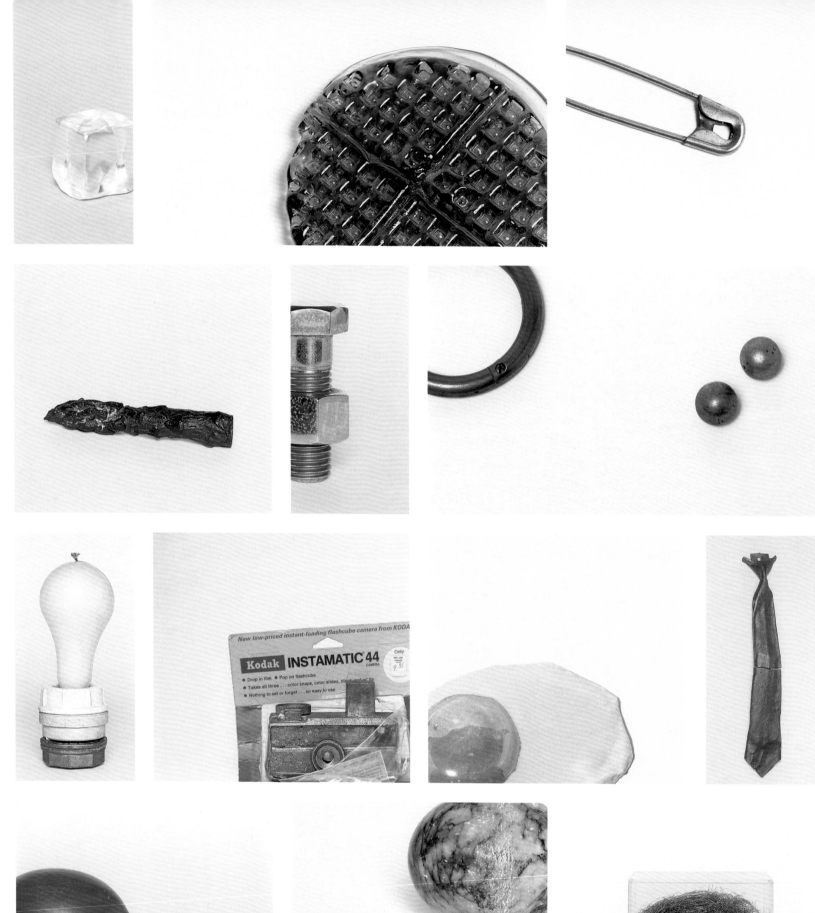

In the universe of correspondences, everything is linked through a surpassing visual and poetic logic. A crumpled cigarette package glimpsed on a sidewalk is somehow the antecedent of the wrinkled linen of Robert Heinecken's photograph TV Dinner/Shrimp. His altered magazines evoke the disjointed seriality of urban advertising. When viewing Heinecken's body of work produced since the 1960s, we plunge into a restless free fall through the storm of disconnected yet profoundly related images and associations that make up our media-saturated world. Heinecken threw out a line to help us find our way, to help us locate the invisible chain of correspondences, when he wrote a "Statement About the Work" in the 1970s. It is reproduced here in large type, accompanied by my description of the Robert Heinecken Archive. My comments are intended as marginalia, reader-annotations to his precisely phrased, organized, and distilled nine-point list of artistic principles. His archive's inner logic may be located somewhere between the methodical structure of his statement and my scattered glimpses of the objects, documents, and fragments he saved and bracketed with meaning.

In understanding the Heinecken archive it is relevant to know that the artist is a poker player and to appreciate that in the game of poker every card in and out of play relates to every other card. From the ace that is really a bluff to the concealed royal flush that wins the hand, the inner logic of the cards or the archive prevails.

77

Objects used by Heinecken to teach his beginning photography classes, ca. 1980s, including: acrylic ice cube, glass waffle, oversized safety pin, cast metal asparagus, oversized nut and bolt, copper ring, small metal spheres, wax light bulb, cast metal Instamatic 44 camera, ceramic fried egg, cast metal hinged necktie, wooden lemon, alabaster egg, and steel wool bird's nest with lead fishing weights.

# I. I attempt to involve myself in work and ideas which constantly challenge that which I previously understood or thought I understood.

The Center for Creative Photography's first director, Harold Jones, acquired the first Heinecken prints for the collection in 1975. The formal arrival of the Robert Heinecken Archive began in March of 1981. It has now grown to over 90 boxes of archive materials and over 500 artworks. With few exceptions, every year has seen an installment of artworks and archival materials, with the greatest number of shipments and the largest volume of materials arriving in the late 1990s when Heinecken cleaned out his Los Angeles home and moved to Chicago. The archive now covers his entire life, with biographical materials ranging from the baby book lovingly assembled by his mother to snapshots made at the party Weston Naef organized when Heinecken moved away from Los Angeles in July 1996.

What escaped the trash can, the studio fire, the divorce, the consolidation of households, the neglectful hand of time?

- The *Aperture* royalty statement from 1996 documenting Heinecken's pending receipt of seventeen cents.
- The brochure from Heinecken's boyhood piano recital at the First Lutheran Church in 1945.
- A large plastic bag filled with political and advertising buttons from the 1960s and 1970s bearing slogans like "Lay, Don't Slay" and "Get Trojans."
- Paper napkins with jottings like "Ambiguous time interests me" and "Maybe I never understood the language of pictures. Did I skip that grade?"
- A file from the 1970 political strikes at UCLA when faculty and students suspended business as usual to protest the university's complicity in U.S. war efforts.
- A copy of Henry Miller's book *Insomnia*. It has burned edges and lots of water damage, and is inscribed by the author, "To Raoul, the mystery man."

- The original, vintage, broken photographic plate of young women in big hats that became the germ of an idea for *14 or 15 Buffalo Ladies,* framed and preserved behind glass.
- A jean jacket, torn, lovingly embroidered, and well worn. In its pocket is a Polaroid of Heinecken wearing the very same jacket.
- A personal note from Diane Arbus scrawled on a page advertising her portfolio of ten photographs, 1971.
- A letter from Mike Mandel asking to borrow money for his Baseball Photographer Trading Cards project.
- A moment in time caught by a photographer attending the Society for Photographic Education meeting in 1973. On the steps of the Pasadena Museum of Art (now the Norton Simon Museum) stand scores of attendees, their shadowy faces less interesting than their 1970s attire. Heinecken's handwriting on the print rescues the figures from oblivion: Duke Baltz, Ellen Brooks, Peter Bunnell, Bob Cumming, Judy Dater, Robert Fichter, Bob Flick, Barbara Kasten, Ellen Land-Weber, Lee Rice, Todd Walker, and others.

## 2. I am interested in the relationships and play between an unfamiliar picture/object context and the familiar photographic image.

The Center's collection of Heinecken's artworks is large, incorporating important work from each decade of his artistic life. The variety of formats, processes, and photographic media is a reminder of the artist's experimentation and interest in new media. The collection includes three-dimensional assemblages, gelatin silver prints, Cibachromes, incorporated color coupler prints, Polaroid SX-70s, Polaroid 20x24s, photoetchings, offset lithographs, printing-out-paper prints, film transparencies, ink jet prints, photograms, manipulated magazines, portfolios, videograms, jetgraph prints, engravings, collages, pencil and chalk drawings, ink transfers, and paintings.

The archive also includes Heinecken's juvenilia—pencil and crayon drawings from grade school and paintings from high school—and his earliest photographic works from the late 1950s.

The majority of his work—over forty percent of the collection—dates from the 1960s. Highlights include *Obscured Figure*, 1964; *Torso in Motion*, 1965; *Figure Cube*, 1965; *Figure Parts*, 1966; *Breast/Bomb*, 1967; several copies of the *Are You Rea* portfolio, 1964-1968; *TV Cube*, 1968; and *14 or 15 Buffalo Ladies*, 1969.

About half of the collection is evenly distributed between works from the 1970s and 1980s. Important works from these years include *Cream Six*, 1970; *Periodical*, numbers 5 through 9, 1971-1972; *Just Good Eats for U Diner*, 1971; *Erogenous Zone System Exercise*, 1972; *Le Voyeur/Robbe-Grillet*, 1972; *Lingerie for a Feminist Suntan*, 1973; *The Evolution of the Hair of the Artist as Aviator*, 1974; *He:/She:*, 1975-1979; *Daytime Color TV Fantasy*, 1974-1975; *Cliché Vary/Lesbianism, Autoeroticism, and Fetishism*, 1975; *Lessons in Posing Subjects*, 1981-1982; *Waking Up in News America*, 1984; and *Recto/Verso*, 1989.

The collection has a few representative later works, including the *PP* series (1988-91) and several images from the *Shiva* series (1991).

## 3. An aspect of the work has to do with altering the literal/cultural meaning of existing public images by making minimal changes and additions. Using superimposition, juxtaposition and other contextual changes, I am functioning as a visual guerrilla.

From his letters and writings, we can derive a Robert Heinecken vocabulary:

Aleatory; appropriation; confused stasis; dichotomies; erogenous zones; expressional vehicles; gestalts; gynandromorphic; lingerie; manufactured experience; pornography; residual photographic illusions; sexual sensibility; serialism; synthesized facture; videograms; visual guerrilla

From a wider reading of the archive emanating from him and surrounding him, we gather a Robert Heinecken geography:

• The polluted paradise of oceanside Los Angeles
• The gritty midwest of lakeside Chicago
• The colored travel lines, spaghetti-style, across a map of the world
• The straight white line of the part in his hair
• The hills and valleys of precisely arranged kimono folds

## 4. I am interested in the various ways that photographic images transcend their relationship to actuality.

When Heinecken was reviewing and organizing his files for the archive, he divided the selected materials into small subgroups, each with an internal theme and organization apart from the larger archive. For example, in 1995, the Center received a large group of materials related to Heinecken's friendships with his students and with other artists. This group included artists' cards and portraits created on the occasion of Heinecken's birthdays, special events in the photographic community, and social occasions. Taken as a whole, these objects form an intimate history of the network of friends surrounding Heinecken and their artistic interaction with him. For example, it is easy to figure out that Heinecken and Robert Fichter have been friends for a long time, but we gain another dimension of understanding when we see a snapshot of them playing pool with Jerry McMillan. We know yet more about Fichter and Heinecken when we see the cartoon Fichter drew on a letter sent from Japan in 1982: Fichter, in his Old Miami Beach T-shirt, too tall to get through the low Japanese doorway without hitting his head; the shorter Heinecken, kimono-clad, saying, "What? Me worry?"

## 5. The pictures and objects are not related to direct experiential camera vision, but represent formalized symbolic equivalents of experience.

Another subgroup covers Heinecken's teaching career of more than thirty years. Many of his printmaking and photography students have now achieved their own degrees of fame, including Uta Barth, Paul Berger, Ellen Brooks, Jo Ann Callis, Darryl Curran, John Divola, Robbert Flick, Jim Hugunin, Victor Landweber, Patrick Nagatani, Lorie Novak, and Kenneth Shorr. Through his teaching files we can see the care he took in devising lectures, slide shows, lesson plans, and assignments. His friendships with students are documented in letters, class registers, gifts, and photographs. We even have a box of inscrutable objects he selected to document aspects of his teaching method. He wrote:

Objects used in teaching beginning photog courses. Idea is that what's interesting about them is not due to manipulation etc. but to a shift in materials, weight, surface, etc. Supposed to make the student believe in the potentiality of the 'real' i.e. photography.

Beyond his commitment to teaching, Heinecken worked to build institutional support for photography across the country in the 1970s and later years. His letters and files contain evidence of his work and his support for the work of others to establish Imageworks (Cambridge, MA), the Center of the Eye (Aspen, CO), Camerawork (San Francisco), the Society for Photographic Education, the Photography Instructors Association, the Creative Experience Workshop, Infill/Phot, and the Center of Photography and Cinematography at the University of Illinois, Urbana-Champaign.

How do mysteries manifest in the orderly, linear presentation of an inventory?

The title on each box conceals its contents from all but the very closely involved. One box labeled "Knute Rockne Oasis Newsletter and Journal of Critical Opinion" is filled with materials related to a unique publication documenting the unorthodox artistic collaboration of Heinecken, Robert Frank, Dave Heath, and John Wood. Created in 1983 by William Johnson and Susie Cohen, the newsletter was sent to perhaps the shortest mailing list ever: the artists themselves. These four very independent practitioners used seed money from Polaroid Corporation to explore their shared interest in words and images, and establish a creative community across the miles. The complex weave of personalities, issues, and results is revealed in the newsletter.

The folder title "Shroud of Turin" could completely throw a reader off the track. In the folder are a few research materials about the Shroud of Turin. There is also graph paper on which shaded cells comprise a Christ-like face when viewed from a distance; a cardboard stencil with paint on the edges; more graph paper with each cell numbered from one to five in an indiscernible pattern. Finally, there is the conclusive bit of evidence: a snapshot of a brick wall that subtly gives up its image—the Shroud of Turin appearing on the brick wall of Heinecken's building in Chicago.

# 6. The figure, because of its human, erotic, sensual and psychological connections, remains my primary subject interest and is the vehicle for the formal content of the work.

Heinecken, studying the world through the alphabet of flesh, is a good scientist. He gathers his data from everywhere: lowbrow, highbrow, *Throb* no less than *Vogue*, the *Berkeley Barb* no less than *Time*. The pornographer, the voyeur, the collector of charged images from the media stewpot, the delictator, the isolator of erotic tension, the demystifier, the anti-pornographer—he needs his sources to be authentic.

In Heinecken's archive we see a pencil sketch from a community college art class. The firm, greasy lines depict a running male figure and to the right is a highly detailed sketch of a woman's sling-back, open-toed, high heel pump. It is not so hard to recognize the shoe in Heinecken's *Cliché Vary/Autoeroticism* of 1974. Also in the archive we see a small collection of smoothly suggestive pinup calendar girls from the late 1940s. We see files of porn mags, envelopes of nudie negatives purchased by mail order or store-bought, and we discover the mother lode of Heinecken's sources: a box of materials labeled "Objects from the wall mural Joy and I made in our studio." The wall is memorialized as a detail in Heinecken's The *S.S. Copyright Project 'On Photography'* from 1978 and as the background of a portrait of Heinecken reproduced in the book titled *Heinecken*, edited by Jim Enyeart and published by The Friends of Photography in association with Light Gallery in 1980. Although the wall itself no longer exists, the archival box allows us to explore the origins of Heinecken's iconography in sexy matchbook covers, ballpoint pens, tourist souvenirs, air fresheners, advertising slogans, playing cards, magazines, and dozens of postcards. The box is a cabinet of curiosities dedicated to consumer culture's assimilation and reformulation of sexuality.

78

7. Often the work relates to my ongoing interest in random and aleatory occurrences and associations. The images are the result of situational rather than visualized stimuli. Synthesis rather than selection is significant.

Heinecken's interest in archiving, inventorying, diagramming, and documenting shows up in the contents and the organization of the archive.

*Archiving*: In a note to the archivist, Heinecken wrote, "I just noticed that even the box I'm using to ship this stuff [in] is part of my history. It is a box for a USMC leather Flying Jacket size 38 made in 1954. If you study the sides of [the box] you will see its various contents since 1954."

*Inventorying*: Files in the archive contain Heinecken's artwork inventories. He made a set of 35mm color slides of works created between 1958 and 1992, which are organized according to page numbers referenced in two sources. Early on, he began keeping the information on 3x5 cards and later transferred this to computer-generated alphabetical and chronological lists.

*Diagramming*: Heinecken's interest in the graphical representation of ideas is evident on paper napkins carried around in his pockets, in formal letters, in his notebooks of writings, and in simple sketches of dichotomies and complex representations of the relatedness of all his work that appear throughout his archive. Sometimes he used blue felt tip pen on brown paper bag, or other times lined notebook paper showing intricate arrows, vertical and horizontal lines to explain the relationship of the various bodies of his work to major themes.

*Documenting*: In a 1985 letter to John Szarkowski, Heinecken wrote:

Dear John: the first notion I have regarding your observation of the condition of the Sontag piece is to clarify that the gradual aging/yellowing process was conceived by me and built in as an integral part of its eventual content. By this I mean that the dichotomies listed in the text…will be resolved by one's careful noting of which picture yellows most and at what rate. (If the left one yellows most, then the right one is correct and vice versa.) I carefully treated the materials in such a way that full yellowing process will take 10 years (This # is related to the zone system ten.)

8. Through my work, I am involved in extending the photographic medium into new processes, concepts and areas of concern and in the utilization of new light sensitive media.

Lesson Number One in working with the Heinecken Archive: Get used to the smell of cigarettes. The visual appearance of Heinecken's handwriting will become welded in your memory to the lingering scent of smoke, which permeates the papers, files, books, and objects.

He has said that he tries to write every day. He writes on anything—paper napkins, 3x5 cards, cheap notebooks, envelopes, legal pads, and even blank books. He reserves typing for formal communication, clearly relishing or needing the kinesthetic experience of handwriting. His angular and somehow humble script progresses evenly and legibly across the pages, filling up blank spots, marching up the margins.

Heinecken, the letter-writer, in keeping the letters he received over the years, created an archive that mirrors the lives and careers of a cross-section of the major figures of the late twentieth-century art and photo world. His letters reveal friendships and collaborations intertwining the paths of people such as Ansel Adams, Peter Bunnell, Carl Chiarenza, A. D. Coleman, Eileen Cowin, Imogen Cunningham, Arthur Danto, Robert Fichter, Ralph Gibson, Betty Hahn, Les Krims, Nathan Lyons, Mike Mandel, Ray Metzker, Barbara Morgan, John Szarkowski, Jerry Uelsmann, and many others. Heinecken's own letters turn up in the archives of Frederick Sommer and Wynn Bullock, astounding those of us who thought we knew the photographic network.

He has not been obsessed with preserving copies of his own letters, but seems to often save drafts along with heavily annotated letters to which he was responding. His letter-writing style is formal yet conversational, getting business out on the table, yet leaving space for a little anarchy. Letters often end, "respectfully yours." The volume of mail now, after thirty-some years of hoarding, constitutes something like a hidden archive of artists' greeting cards, mail art, postcard art, photographic cards, joke art, titillating art, insider art, naïve art.

No one has collated and indexed his critical writings, his poetry, or his lectures, but the drafts and polished versions appear in the archive, randomly scattered (or are they carefully dispersed?) across the files so that the researcher encounters them again and again in different contexts, different formats. Some of the titles include: "I am Involved in Learning to Perceive and Use Light," "Manipulative Photography," "A History of Photography," and "Photography into Sculpture."

9. My basic aim is to be able to relate the concept and content of the last piece to the next, so as to be involved in the constant development of individual subjective work. I value the open-ended evolution of ideas as opposed to a particularized esthetic resolution.

Although the Heinecken Archive is large and made up of seemingly disparate elements, an inner logic is revealed through the inventory.

*Biographical materials (1931-1999):* Date books, appointment calendars, resumés, autobiographical and biographical sketches, student artwork, interviews, high school yearbooks, artifacts from his United States Marine Corps career, family correspondence, ephemera from childhood, a baby album, and many portraits of Heinecken (20 boxes).

*Correspondence (1970s-1999):* Letters and cards received from friends, museum curators, gallery owners, critics, fellow photographers, teachers, students, publishers, writers, and other cultural figures; occasionally includes multiple drafts and final versions of Heinecken's own outbound letters (6 boxes).

*Writing files (1970s-1990s):* Drafts of lectures, lecture notes on 3x5 cards, course descriptions, responses to reviews and exhibitions, and Heinecken's extensive writings on his work and ideas (2 boxes).

*Publication files (1970s-1990s):* Manuscripts, book design materials, dummy pages, interviews, notes, and related materials documenting Heinecken's publications, especially *Heinecken* (1980), edited by James Enyeart and "Knute Rockne Oasis Newsletter" (1983-1984), edited by William Johnson and Susie Cohen (6 boxes).

*Exhibition files (1960s-1999):* Materials collected and organized by Heinecken, such as announcements, installation views, correspondence, invoices, and exhibition publications from 1964 to 1990 for solo and group exhibitions (5 boxes).

*Artwork inventories and bibliographies (1958-1992):* 2,272 color 35mm slides of what Heinecken called his "relevant work"; index recorded on 3x5 cards and a computer-generated alphabetical and chronological list (1 box).

*Project files (1960s-1990s):* Extensive files of production materials, including negatives, transparencies, photo-litho printing plates, projects in preliminary pieces, incomplete projects, collage materials, mounted images, annotated proofs, raw materials for various altered periodicals, and miscellaneous documentation of projects (10 boxes).

*Reference files:* Reference materials collected by Heinecken, including published articles, manuscripts, and printed materials relating to photographic criticism and education (1 box).

*Activity files:* Materials relating to teaching and participation in photography organizations (2 boxes).

*UCLA teaching files:* Biographical and bibliographical materials produced and collected by Heinecken and used in attaining promotions and sabbaticals at the University of California, Los Angeles (1 box).

*Audio-visual materials:* Audio and videotapes of Heinecken lecturing and being interviewed, and the slides he used in lectures. Of special note are the fourteen videotapes made by CCP staff during the August 1995 graduate seminar Heinecken taught at the University of Arizona (30 boxes).

*Miscellaneous oversize materials:* Posters, large portraits, artwork by Heinecken's children, a decorated toilet seat, Heinecken's heavily embroidered jean jacket (6 boxes).

# NOT THE LAST WORD

ROXANE RAMOS

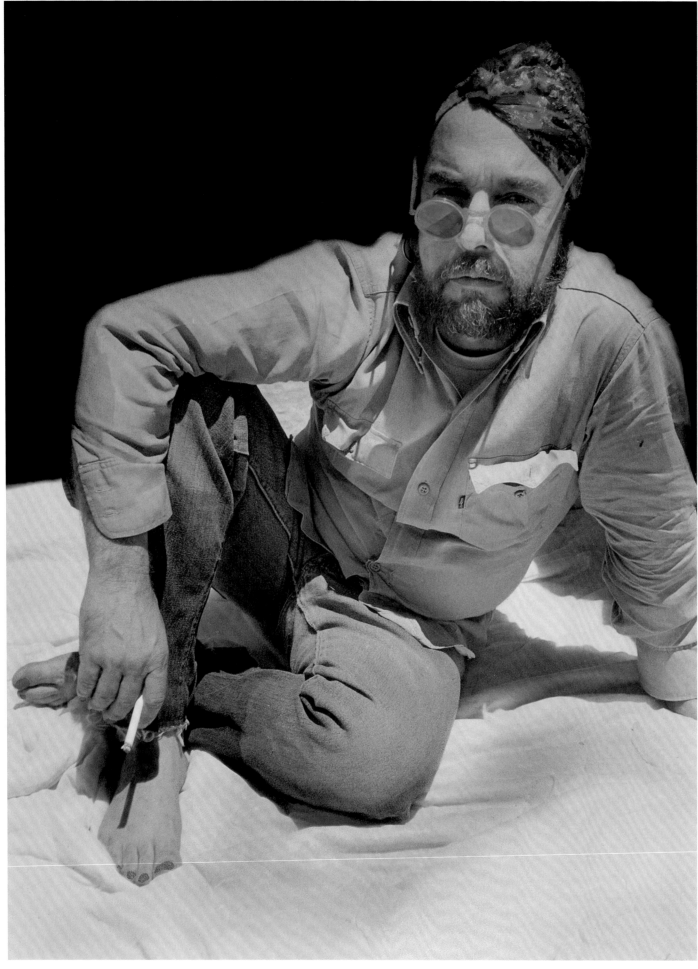

We've all had the experience of returning, years after our first encounter, to a book, a movie, a work of art, only to discover something new, unexpected, perhaps even contradicting our initial impressions. The most basic illustration from my own life centers on *The Sun Also Rises,* first read when I was sixteen under the illuminating, if cautious, tutelage of Sister Loretta who loved literature, but hated sin. Back then the book confounded me. Why did these characters behave in such cryptic, cranky ways? Why the strange push-pull dance in their dialogue? Twenty years later I read the book again and could easily discern what Hemingway deftly portrays and Sister Loretta avoided—off-page, sex was going on, with all its familiar territoriality and evasiveness, overt and subliminal.

For Robert Heinecken, sex and sin have been far less peripheral, serving more as centerpiece than backdrop. Like Hemingway, he too has weathered accusations of sexism and misogyny. Not surprisingly, Heinecken's work can make some viewers feel uncomfortable, either squirmy or alienated. Even so, Heinecken's art, like Hemingway's, merits repeated engagement, particularly because of the complicated reactions it engenders. Decades after Heinecken created some of his most famous (or notorious) portfolios and series, a reassessment is due.

Archives inform and deepen this experience. While the work itself proclaims an artist's legacy, an archive reveals how that reputation was made. It provides an opportunity to review an artist's methods and intentions, to seek answers to questions and then pose new ones, to explore theses and draw fresh conclusions. The documents and artifacts in an archive become more than mere objects when animated by our curiosity and imagination. With each encounter, our apprehension of materials and their meaning can change, not only because we do, but because the times reframe the record.

Such is the case with the Robert Heinecken Archive, established in 1981 with additions almost every year since. Over the ensuing decades, the archive has grown to 90 boxes of archival materials (which include Heinecken's baby book, birthday cards, teaching materials, and carefully organized production materials) and more than 500 art works. Because Heinecken drew his inspiration and imagery from pop culture and its attendant media madness, his archive is something of a post-WWII time capsule—airplanes, big hair, come-hither looks, the Marlboro Man, Vietnam, peace and love, the gender wars, Ronald Reagan,

79
Jo Ann Callis
VALENTINO HEINECKEN
1974, Hand-colored gelatin silver print

Gap ads. Did Heinecken wear khakis? Judging from the numerous portraits by friends and colleagues, no. Denim, with its timeless cool and labor roots, appears to have been his garb of choice, though he accessorized on occasion. A photograph by Jo Ann Callis depicts Heinecken, swami-like, sporting a turban and his signature cigarette.

That Heinecken could embody different personas (a phenomenon that has as much to do with the evaluator's predisposition as Heinecken's eclecticism) is evident not only from snapshots, but from the way in which various groups have adopted (or scourged) him over the years. Heinecken rarely took photographs; yet his work has broadened our definition of what photographic endeavor may encompass. Indeed, it is precisely because of his unorthodox methods that Heinecken has established himself as one of the major contributors to the medium in the second half of the twentieth century.

Artist and writer Mark Alice Durant assesses the significance of this idiosyncratic career, acknowledging Heinecken's particular obsessions and reconsidering his unique contributions as both an educator and practitioner. Innovative and engaging in his own work, Mark is not one to shy away from self-implication; here he includes a triptych of memories—his own—to illustrate and illuminate those rites of passage which shape our notions of self, sex, masculinity and femininity.

In fact, both contributors to this book merge personal reflection with professional insight. CCP archivist Amy Rule adds an overview of the archive that mingles interpretation and inventory, order and improvisation, much like Heinecken's work. Amy retains an infectious fascination with narrative. Each archive holds a wealth of stories waiting to be told and she is an avid investigator and translator of those tales.

And so the conversation continues—across miles and over time, among writers, curators, educators, art historians, and lovers of the medium. History, photographic or otherwise, is an iterative enterprise—it is written and revised again and again, and as subsequent generations add to the record, entire genealogies are remapped. This volume is but an installment, an invitation to further dialogue about the scope and impact of the Heinecken legacy. It stands as the latest chapter, but undoubtedly not the last.

## Acknowledgments

A CCP publication is the product of the cooperation and dedication of everyone on staff. To all of them, I extend my deep appreciation, especially: Terence Pitts, Nancy Lutz, Trudy Wilner Stack, and Pat Evans for their initial work on the project; Leslie Calmes and Marcia Tiede for their impeccable research; Denise Gosé and Dianne Nilsen for their meticulous reproductions of imagery and objects; Landis Kearnon and Betsi Meissner for their discerning editorial skills; Heather Barnes, Matthew Ehler, and Shaw Kinsley for their communications and research support; and Amy Rule for her ever-reliable guidance and insight. My sincere thanks go to Mark Alice Durant who contributed well beyond his role as author to offer valuable ideas and solutions throughout the production process and to Robert Gallerani of Godat Design who transformed our long wish list of "requirements" into an exciting and coherent book design. Finally, this book is a celebration of the Robert Heinecken Archive and the career of a generous artist, teacher, and friend to the Center for Creative Photography. To him, our unwavering gratitude.

**ROXANE RAMOS**
Editor

# Contributors

Mark Alice Durant has written extensively on the nexus of photography, perform-
ance, and cultural phenomena for *Art in America, New Art Examiner, Exposure,
Afterimage,* and the *Boston Book Review.* He has authored or contributed to
a wide range of publications, including *McDermott and McGough: A History of
Photography* (Arena Editions, 1998), *Vik Muniz: Seeing Is Believing* (Arena Editions,
1998), *The Passionate Camera: Photography and Bodies of Desire* (Routledge,
1998), *Mark Romanek: Music Video Stills* (Tondo, 1999), *Dressed for Thrills:
100 Years of Halloween Costumes and Masquerade* (Abrams, 2002), and *Some
Assembly Required: Collage Culture in Post-War America* (Everson Museum,
2002, for an exhibition he co-curated). His photographs, installations, and per-
formances have been presented internationally. He has taught at the School
of the Art Institute of Chicago, UCLA, the University of New Mexico, and
Syracuse University. Currently, he is Associate Professor in the Department of
Visual Arts at the University of Maryland, Baltimore County, and a faculty member
of the Milton Avery Graduate School of the Arts at Bard College.

Amy Rule, Archivist at CCP, has authored and edited a number of photography
publications, including the *World Photographers Reference Series* (ABC/Clio
Press, 1989-1997) and, most recently, *Original Sources: Art and Archives at the
Center for Creative Photography* (CCP, 2002). In addition, she has published in
numerous photography, art, and art history periodicals, among them *Exposure,
History of Photography,* and *Visual Resources.* During more than two decades
with CCP, she has facilitated the expansion of the research collections and
worked with hundreds of photographers and researchers. Her experience at
CCP has helped shape her conviction that photography can be approached from
multiple and ever-evolving research perspectives.

C ( P

All reproductions of images from the CCP fine print collection
are designated with accession numbers; all other reproductions
depict objects and ephemera from the research collection of
the Robert Heinecken Archive.

All works by Robert Heinecken © Robert Heinecken

*Robert Heinecken: A Material History* © 2003 Mark Alice Durant

Portrait of Robert Heinecken on page 9 has been reproduced with
the permission of Jerry N. Uelsmann. © 1973 Jerry N. Uelsmann

*Afterimage* covers on page 12 have been reproduced with the
permission of *Afterimage: The Journal of Media Arts and Criticism.*

*Valentino Heinecken* on page 106 has been reproduced with the
permission of Jo Ann Callis. © 1974 Jo Ann Callis

ISBN: 0-938262-36-X

Editor: Roxane Ramos
Editorial Assistance: Landis Kearnon, Betsi Meissner,
Amy Rule, Marcia Tiede
Research: Leslie Calmes, Marcia Tiede
Photography: Denise Gosé, Dianne Nilsen
Design: Godat Design, Tucson, AZ
Printing: Imperial Lithograph, Phoenix, AZ

Distributed by D.A.P./ Distributed Art Publishers, Inc.
155 Sixth Avenue, New York, NY, 10013
Telephone: 800-338-2665
Website: www.artbook.com

Front cover: Detail from magazine page printed with
offset lithograph image, 1971
Back cover: Detail from *Toy Prostitute*, 1965
Flyleaves: From Heinecken's button collection, n.d.

Center for Creative Photography
The University of Arizona
P.O. Box 210103
Tucson, Arizona 85721-0103
520-621-7968 phone
520-621-9444 fax
www.creativephotography.org

DRAFT CARDINAL SPELLMAN

ER IL TY RITES

MULTIPLY

I'M FOR SEXUAL FREEDOM

MAKE DON'T HATE

OPEN YOUR MIND AND SAY AHHH!

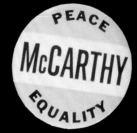
PEACE McCARTHY EQUALITY

BAN BUTTONS

BATMAN & ROBIN

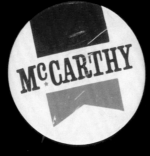
McCARTHY

LET'S GROK!

000101

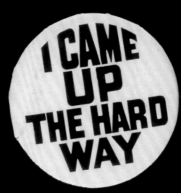
I CAME UP THE HARD WAY

EXCITEMEN BUTTON

MORE DEVIATION LESS POPULATION

PLAN AHEAD USE CONTRA-CEPTIVES

P.O.T. WOLFMAN SUCKS (ONLY DURING THE FULL MOON)

USE EROGENOUS ZONE NUMBERS

make a friend

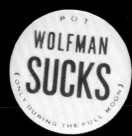
FELLATIO

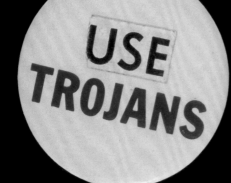
USE TROJANS

MELVILLE EATS BLUBBER

LOVE POWER

PRAY FOR THE SOULS IN PURGATORY

CURE VIRGINITY

LET PROSTITUTES WORK

LET'S LOVE ONE ANOTHER

LEGALIZE NECROPHELIA

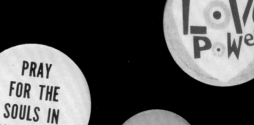
LOVE IS GOD

BRING BACK PAGANISM

planned parenthood kes the worry out of being

SEX IS MY BAG

GOD ISN'T DEAD